minimal graphics

ROCKPORT

minimal graphics

the powerful new look
of graphic design

GLOUCESTER MASSACHUSETTS

ROCKPORT
PUBLISHERS

Catharine Fishel

First published in the United States of America by:
Rockport Publishers, Inc.
33 Commercial Street
Gloucester, Massachusetts 01930-5089
Telephone: (978) 282-9590
Facsimile: (978) 283-2742

Distributed to the book trade and art trade in the United
States by:
North Light Books, an imprint of
F & W Publications
1507 Dana Avenue
Cincinnati, Ohio 45207
Telephone: (800) 289-0963

Other distribution by:
Rockport Publishers, Inc.
Gloucester, Massachusetts 01930-5089

Designer: Stoltze Design

ISBN 1-56496-628-3

10 9 8 7 6 5 4 3

Printed in China

minima

the powerful new look of graphic design

To my Mom and Dad, Nancy and Alan George, who gave their blessing to a liberal arts degree even though they were a little concerned about how one makes a living as a liberal artist.

con-
tents

intro

duction

What is minimal? As I collected material for this book, it was easier to define what minimal is not. In terms of graphic design, minimal does not mean blank, empty, devoid, or even quiet. It does not permit the gratuitous use of white space. It absolutely is not a safety net for lack of content. ■ In fact, minimal directly opposes all these things. Minimal graphic design, stripped of incidental references and pared down to its most essential elements, presents a purely intellectual or visual experience. As the extreme minimalist Ad Reinhardt said, "Art is art. Everything else is everything else."

Minimal design is everywhere today. Furniture design has circled back to pure, geometric forms. Favored fabrics are monochromatic, relying more on embedded pattern than color to add interest. Even clothing has adopted boxier, non-defining shapes. Many would suggest that graphic design's shift back to its more elemental nature has done much to lead these other design fields back to basics.

What jump-started the return to a more minimal philosophy? The visual pendulum's natural swing is a likely cause: After a decade of distended, layered, filtered, fragmented, disordered, and reassembled graphics, people want something fresh. The natural place to look for it is in the extreme opposite direction. Maybe, simply exhausted by the incredible pace of life today, people crave respite in their environments. Or, perhaps, designers have tired of diddling with technology and have refocused their attention on the real business of design: to communicate. ■ Although computers can present formidable challenges, the amount of effort necessary to produce a truly minimal design is probably even greater. To liberate a message completely from the extraneous is extremely difficult.

A set of advertisements by Clarke Goward of Boston demonstrates how a very basic tool set can produce memorable design, even for a product that is not particularly sexy. The ads also outline the sections of this book.

minimal **color** ■ A simple, clear color palette relates and differentiates the ads simultaneously. The pieces attract the eye when seen alone or as a set.

minimal **type** ■ The simple headline and diminutive copy block don't intimidate. In fact, their humor and economy viscerally deliver the same calming benefit promised by the product.

minimal **grid** ■ The basic, repeating grid is elegantly simple. It serves as a sort of secondary identity for the product: Readers easily learn to recognize the format.

minimal **image** ■ The image couldn't be more simple—just a photo of the product repeated over and over.

minimal **message** ■ The copy delivers its message with humor and understanding. The design offers the reader's eyes a calm place to rest.

minimal **package** ■ The ads don't recreate the wheel with each revolution. The repeating format, because of its simple design, isn't tiresome. Instead, it acts as a beautifully invisible frame for the message.

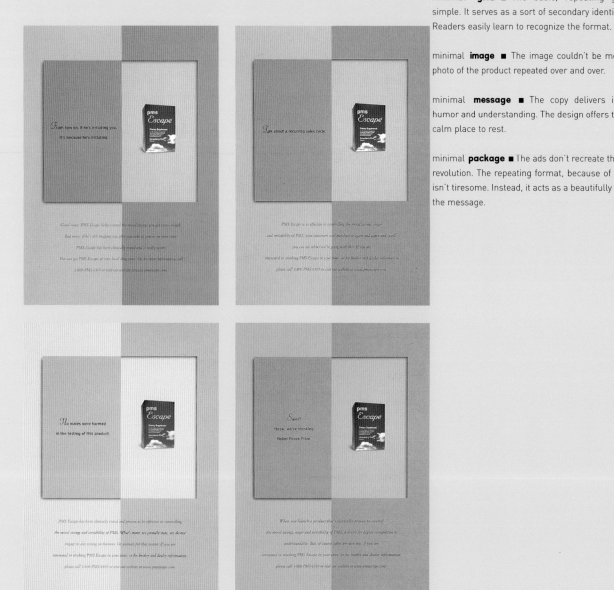

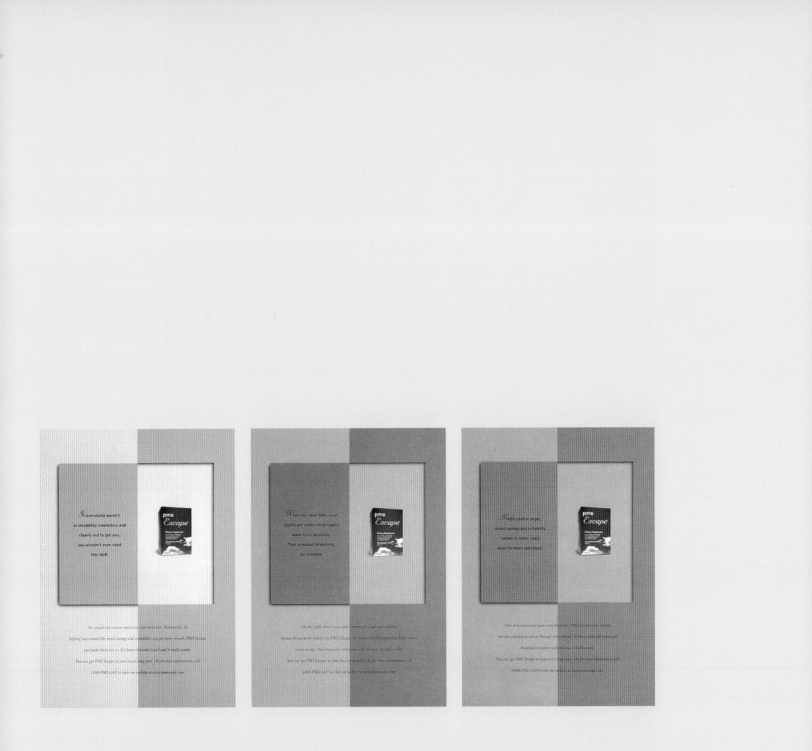

If you check out any design magazine from the last several years, you'll find graphics of all kinds becoming more and more refined. Layouts are cleaner.Communication is much more direct. Is the spirit of the Bauhaus more forcefully surfacing from the public psyche? Modernism is back. If you're a colorist at heart, you're in your element. ■ But instead of assuming that everything is unabashedly derivative, it's somehow more heartening to think that today's minimal movement might be a wholesome return to roots, a re-centering of design that will cause designers to reconsider their role in a very overwhelming world—to make the way clear for understanding.

-Catharine M.
Fishel

I.

minimal
color

Color has the amazing ability to bypass the intellect and shoot directly into the emotional well deep within everyone. Around the world, colors' meanings resonate in ways that spoken or written words cannot replicate. Color tickles and prods, agitates and comforts. ■ The selections in the following pages don't follow any firm definition of color: Some boldly proclaim themselves, others understate. Still others present simple black and white. ■ What connects the images is theireffective use of tone as communication. Each color signifies; none simply decorates.

UCLA Summer Sessions 1998
www.summer.ucla.edu

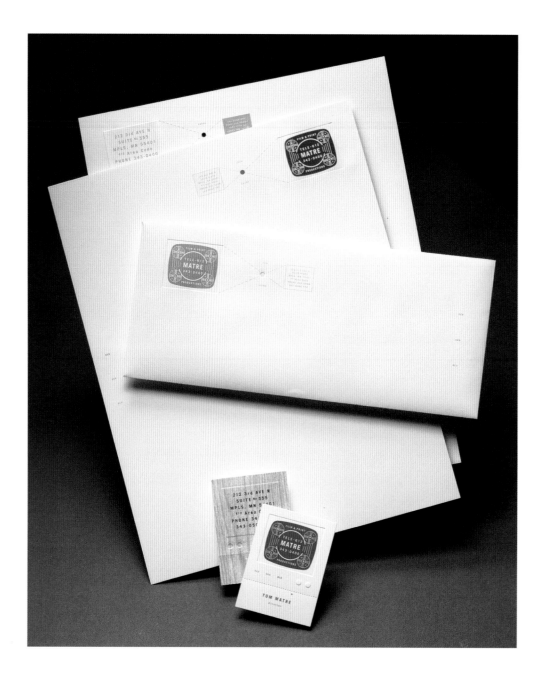

design firm	Haley Johnson Design Co.
designer	Richard Boynton
copywriter	Richard Boynton
illustrator	Haley Johnson

Matre Productions Stationery ■ Because Matre Productions specializes in 15- and 30-second television spots, Haley Johnson Design focused on very basic TV associations to create its identity. First, the mark itself is built around an icon familiar at least to older viewers, an old TV test pattern. Second, the use of red, green, and blue on alternate pieces of the stationery speaks of television's RGB environment. Finally, both the mark and address information appear to be projected from a drilled hole or embossed circle. The hole or circle symbolizes focus, analogous to the hole in an old-fashioned camera that allows the operator to focus on images and allows light in to expose the film.

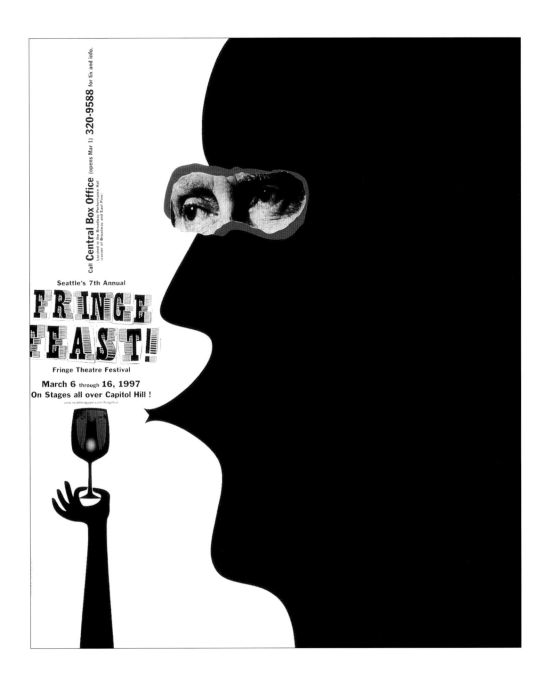

design firm Modern Dog
art director Michael Strassburger
designer Michael Strassburger
illustrator Michael Strassburger
printing The Copy Co., Seattle

Seattle Fringe Feast Festival Poster ■ Organizers of Fringe Feast, an annual Seattle fringe theater festival in its seventh year, granted Modern Dog complete freedom to create the 1997 poster. So the firm concentrated on creating an image that would be recognized easily when pasted on a wall full of posters. The large, black, kissing face—symbolic of faceless masses sniffing and peering into the world of fringe theater—was hard to miss. However odd or funky the performance experience, the face of the festival audience offers a puckered "bravo!"

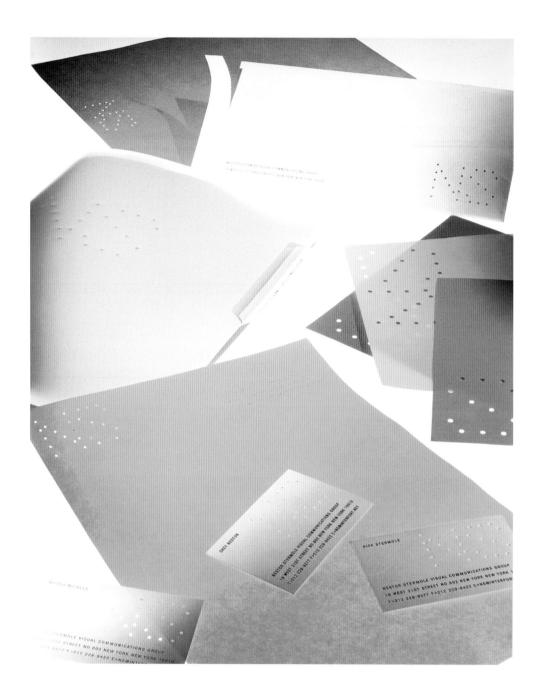

design firm Nestor-Stermole Visual Communications

Nestor-Stermole Stationery ■ When the founders of Nestor-Stermole were searching for a way to visually connect the *N* and *S* in their logo, they considered specialty processes such as embossing and letterpress. But the decision to use laser-die-cut holes and a coordinated system of richly colored papers brought the design to life. In addition to having a clean, modern look, the holes also allow other colors in the system to show through from behind. The hole metaphor has since been continued on disk stickers, the office's door sign, and even napkins for the company's Christmas party.

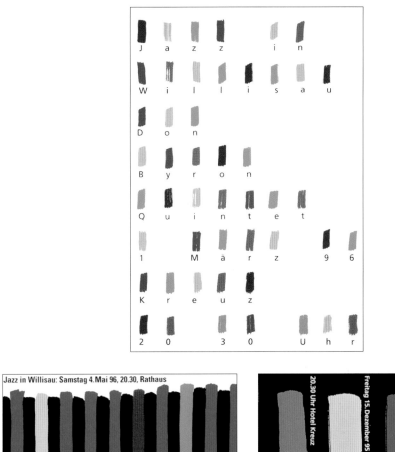

design firm Niklaus Troxler Grafik Studio

Jazz In Willisau Posters ■ For his poster designs for the Jazz in Willisau annual performance event, designer Niklaus Troxler selects strong, clear colors for their emotional impact as well as for their contrast. Samples from three separate years are shown here. Because they are used outside on official poster walls, sometimes next to commercial posters, each design must be extremely simple and clean in order to stand out.

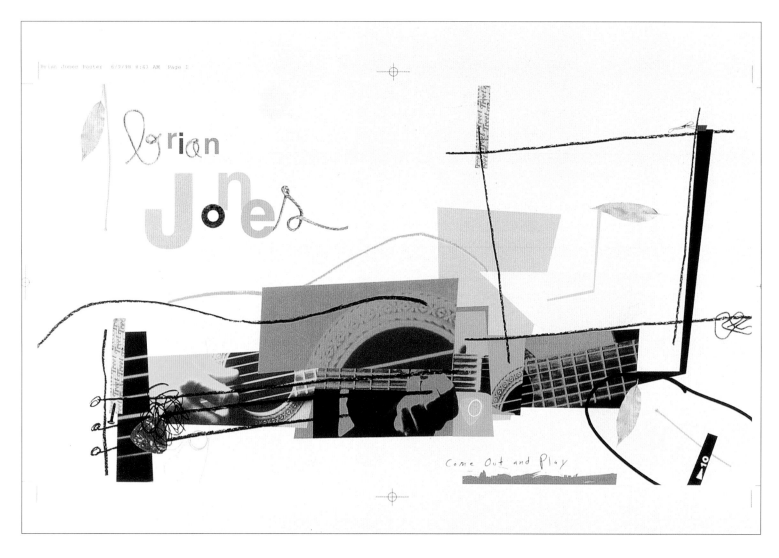

design firm	The Partnership
creative director	David Arnold
art director	David Arnold
designer	Anne-Davnes Dusenberry
illustrator	Anne-Davnes Dusenberry
photographer	Arrington Hendley

Brian Jones Album Promotion ■ The color in this poster image for musician Brian Jones's first album, titled *Come Out and Play*, harmoniously recedes to allow posterized imagery, found objects like picks and strings, and the subtle female-like form they create to emerge. The album's recurring theme was male/female love relationships, and designers at The Partnership gave the artwork an almost humorous aspect: It seems as though the musician is almost romancing his audience through his music. The image of the female/guitar is both the object of his affection as well as the vehicle of romance.

SUN(P)ARK

design firm George Tscherny, Inc.

designer George Tscherny

Sunpark Logo ■ Sunpark offers parking facilities, mostly adjacent to airports. George Tscherny, of George Tscherny, Inc., noted a fortunate coincidence at the center of the client's name—the letter *P*—the same universal symbol for parking. So he placed the *P* in a red circle familiar from the standard symbol, placed the new symbol in the center of the client name, and an extremely simple, extremely elegant logo was born.

"Raising funds for the American Cancer Society was the answer to my prayers.

In the hospital after my surgery, I begged God to let me give something back.

You see, I have survived. I have known the fear of losing someone I loved.

But I have also known the joy of good news."

SHIRLEY'S LIFE HAS BEEN FLOODED WITH CANCER, BUT SHE HAS NOT BEEN OVERCOME.
SHE LOST HER FATHER TO CANCER. TWO YEARS LATER, HER MOTHER LOST A 25-YEAR BATTLE WITH THE DISEASE. SHIRLEY FELT THE ISOLATION OF BEING STRONG. SHE WAS THE ONE WHO NEVER CRIED AND ALWAYS SAID SOMETHING POSITIVE.
SEVERAL YEARS AGO, SHE LEARNED CANCER HAD INFECTED HER COLON, BUT SURGERY REMOVED THE MALIGNANCY. HER HUSBAND IS ALSO A SURVIVOR.

Shirley Kraus

Today she drives patients to and from hospitals as a Road to Recovery volunteer. She says that with the turn of her ignition key, she shows people that there is someone who cares. More than 200 cancer patients were driven to and from treatments last year by Road to Recovery volunteers.

TOM SMOKED A PACK A DAY FOR 26 YEARS. ON HIS DAUGHTER'S SECOND BIRTHDAY, HE TOOK A HARD LOOK AT HIS LIFE AND THE CHILD HE ADORES. HE REALIZED HE HAD TO STOP BEFORE IT WAS TOO LATE. HE TURNED TO THE AMERICAN CANCER SOCIETY TO KICK THE HABIT. THE FRESH START PROGRAM SHOWED HIM HOW, AND HE HAS NOT SMOKED A CIGARETTE SINCE.

Tom Frank

Now Tom volunteers as a Fresh Start facilitator and helps others face their fear of quitting. He is the first one to say how hard it is to quit. There are no magic pills, no easy ways out of this deadly addiction. But if you have the will, you can quit. Tom is living proof. And so are the 500 people who Tom and 30 other volunteer facilitators helped kick the habit last year.

Tom is an independent business man who devotes time every week to helping others. Now he says he is disgusted by the smell of smoke. It's a day he never thought would come.

"The pain of trying to quit smoking could never compare to the pain of having my daughter grow up without a dad."

design firm Geer Design
art director Mark Geer
designers Mark Geer, Karen Malnar
copywriter Richelle Perrone
photographer Chris Shinn

American Cancer Society Annual Report ■ The American Cancer Society's Houston office wanted to develop a marketing piece that could be use to solicit funds, recruit volunteers, and disseminate general information to the public. Geer Design's idea for the superimposed images came from trying to create a single visual that quickly conveyed the services provided by the ACS. This approach suggested the people that are truly behind the service. The warm colors were selected primarily for aesthetics, but also to reinforce the idea that, while cancer is often life-threatening, research offers hope to those who develop it.

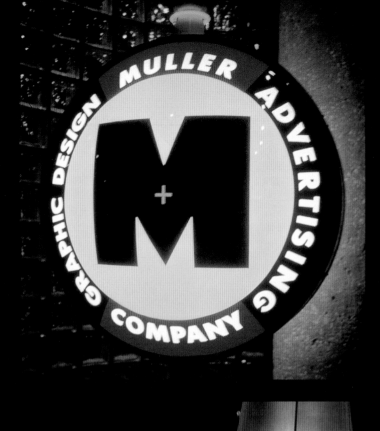

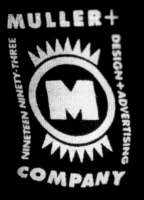

design firm Muller + Company
designer John Muller

Muller + Company Logo ■ The bold, basic look of Muller + Company's logo hearkens back to simpler times: Principal John Muller says contrasting yellow against black speaks of old-style gas station signs. Muller calls the mark an "antilogo," not a cute or clever visual but something more like signage. The extreme simplicity of the logo makes it memorable and allows it to be infinitely flexible. The mark has been used on 3-D signs, ceiling panels, doorknobs, car stickers, T-shirts, and more, in addition to the firm's stationery system.

A little something on Aside.

design firm Fairly Painless Advertising
creative director Peter Bel
designer Dolph Kawalec
copywriter Judy Bean
photographer Maria Krajcirovic

Herman Miller Aside Brochure ■ The overall objective of this Herman Miller Aside brochure, designed by Fairly Painless Advertising, was to infuse the product with a personality of its own. The design borrowed from Herman Miller's "SQA"—simple, quick, and affordable—way of buying office furniture. The simple palette and photographic concepts emerged from a creative one-upmanship contest between writer Judy Bean and designer Dolph Kawalec: Together, they pursued "asides" from the sublime to the ridiculous—"asidewalk," "asideburn," "asideswipe," and "asidewinder." The last spread of the brochure presents the Aside product line.

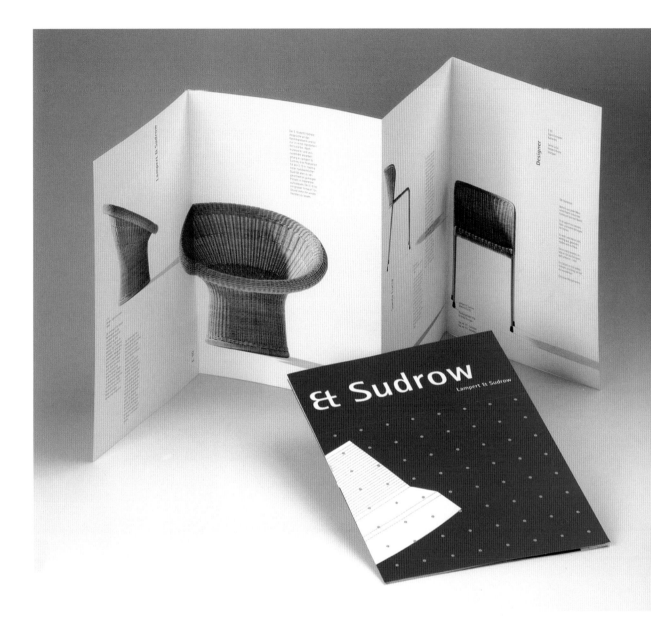

design firm Baumann + Baumann
designers Gerd Baumann, Barbara Baumann

Lambert Et Sudrow Brochures ■ Lampert Et Sudrow produces and sells well-designed furniture and other long-life products. Its promotional materials, targeted at architects and high-level furniture shops, need to reflect its design-conscious stance. Baumann + Baumann has created a number of striking brochures and booklets for the company, including these vibrant designs. The folders can be used folded as brochures or unfolded as posters. The geometric dot patterns are picked up from the furnitures' drafting drawings, placed to indicate punched-steel panels on the furniture.

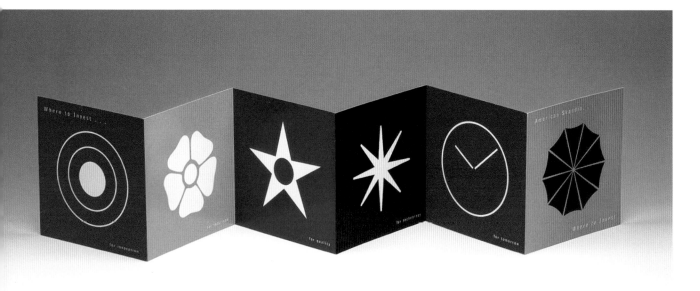

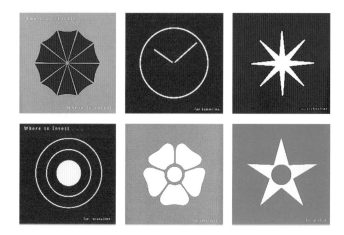

design firm Nuhn Design
art director Peter W. Nuhn

American Skandia Foldout ■ When Peter Nuhn created this brochure for American Skandia, an investor service company, he based the client's corporate identity on 1960s American folk and pop art iconography. He used strong elemental graphics to represent and telegraph different aspects of the client's business message: a bull's-eye for problem solving, a flower for investment growth, a star for superior service, a starburst for technology, a clock face for the future, and an umbrella-like symbol to represent the company itself. Nuhn says he specified the accordion fold so that the booklet can be read in a circular manner: The reader can enter the information printed on the opposite side of the images at any point.

design firm Nuhn Design
art director Peter W. Nuhn
designer Peter W. Nuhn

Fletcher Cameron Furniture Logo ■ Fletcher Cameron Furniture needed a logo that represented its philosophy of furniture making: geometric proportions, hard-edged materials, mechanical. To reflect this attitude, Peter Nuhn decided to base his logo design on pure forms and colors. The arrangement of shapes and colors, says Nuhn, was not consciously meant to have any meaning other than to reflect the client's design style and systematic approach. Some, though, see a sideways face or a room full of furniture.

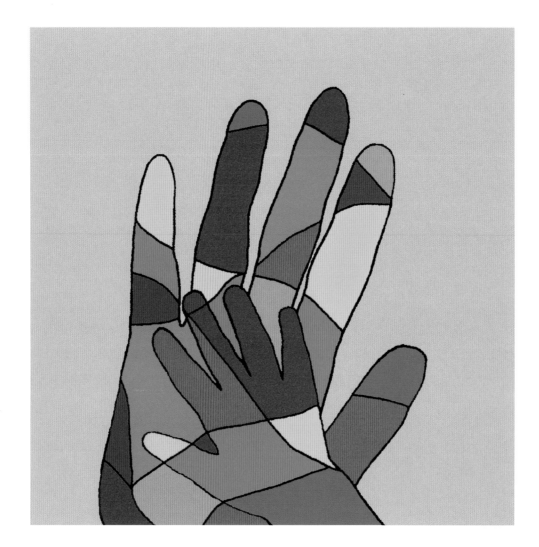

design firm Nuhn Design
art director Peter W. Nuhn
designer Peter W. Nuhn

Yale–New Haven Hospital Logo ■ Peter Nuhn originally developed this art for a thank-you poster to follow a fund-raising campaign at a children's hospital. But the client liked the results so much that he chose the image as a logo for its ongoing development campaign. Nuhn says the art symbolizes one hand—be it individual or corporate—helping another. A form of drawing play the designer learned as a child forms the image: He traced his hand and that of a younger friend, then randomly drew lines through them and colored the resulting shapes.

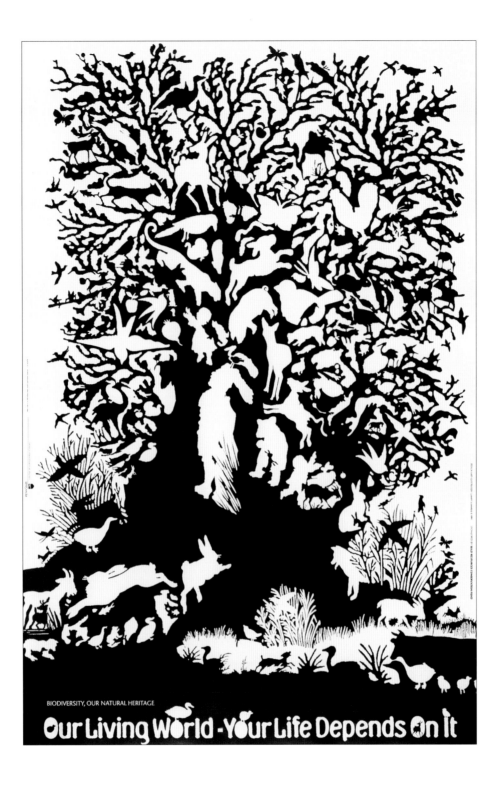

BIODIVERSITY, OUR NATURAL HERITAGE

Our Living World - Your Life Depends On It

design firm Sommese Design
art director Lanny Sommese
designer Lanny Sommese
illustrator Lanny Sommese

Our Living World Poster ■ Designer Lanny Sommese worked out this intricate mix of positive and negative space by hand. Sent to schools across Pennsylvania from Pennsylvania State University's College of Agriculture and the Wild Resources Conservation Fund, the 24-by-36-inch poster features a variety of plants and animals indigenous to the state. Sommese wanted to demonstrate graphically the species' interdependence. He drew some of the shapes and traced others from various sources, then he filled all the shapes to create silhouettes. Some of these were reversed to create positive shapes. Each piece was photocopied and placed individually. Sommese paid particular attention to the edges of the tree and how they related to the cut edge of the poster, striving always to keep those areas visually interesting. The designer says his favorite parts of the poster are where an edge of a positive imagealso forms the edge of a negative image. The optical illusion this juxtaposition creates, he says, gives the image real visual zest.

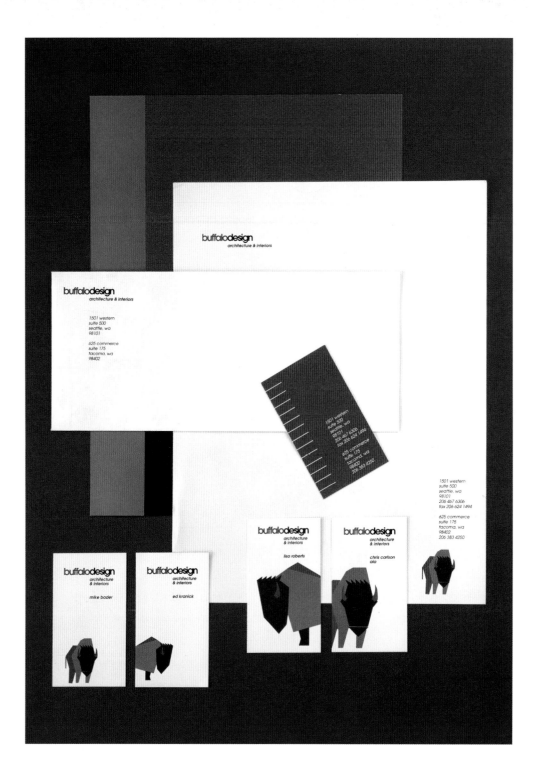

design firm Paper Scissors Stone

designers Scott Cameron, Lisa Ewing

Buffalo Design Letterhead ■ Buffalo Design has an interesting story behind its moniker. The name came from the firm's first project: to develop architectural studies for renovations to glass artist Dale Chihuly's studio, which was located in Seattle's Buffalo Building, so named for its original resident, the Buffalo Shoe Company. Later, the architectural firm was housed temporarily in the same building, and its original logo was a charging buffalo. On its tenth anniversary, the firm's principal created a new, collaged logo. Paper Scissors Stone took the new logo and turned it to show all or part of it on different parts of the system. The logo will remain the same, but its colors, says designer Scott Cameron, will change with fashion. The tick marks on the back of the business card speak of architectural accuracy, but they are also functional: In a pinch, they can act as the 1/4-inch-equals-1-inch architectural scale.

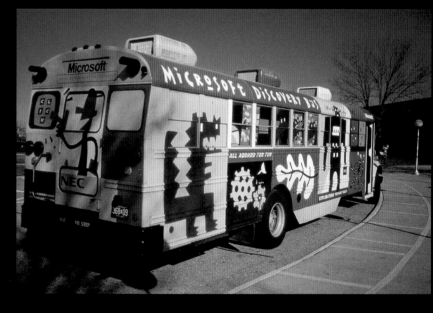

design firm Sandstrom Design
art director George Vogt
designer Michael Bartalos
illustrator Michael Bartalos

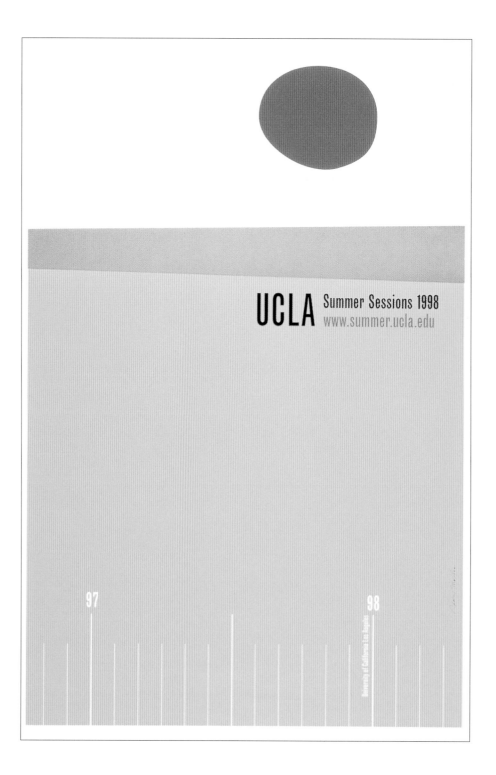

design firm AdamsMorioka
creative director Sean Adams
designers Sean Adams, Noreen Morioka

UCLA Catalog Cover ■ Conveying the ideas of Los Angeles, summer, and UCLA was AdamsMorioka's goal for this UCLA summer session catalog. To find their solution, the designers made a list of symbols for each idea—Los Angeles, the beach, summer, and so on. Then they began making the symbols real, through shape and color. Rendered in cut paper, scanned, and combined with type, the final design not only achieves the assignment's original goals, it also uses the school's colors.

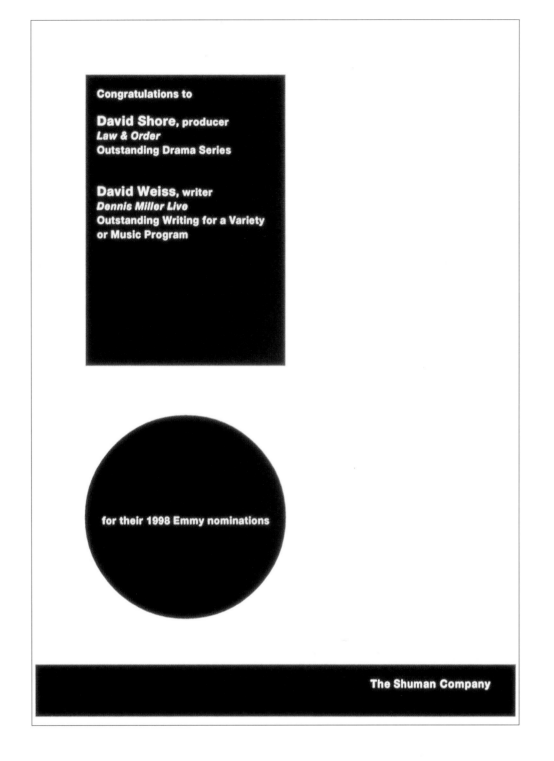

Congratulations to

David Shore, producer
Law & Order
Outstanding Drama Series

David Weiss, writer
Dennis Miller Live
**Outstanding Writing for a Variety
or Music Program**

for their 1998 Emmy nominations

The Shuman Company

design firm AdamsMorioka
creative director Sean Adams
designer Sean Adams

Shuman Company Variety Ad ■ Produced to go on the back page of *Variety* magazine, a very densely packed publication, this ad is purposely more spare. AdamsMorioka client The Shuman Company, a talent agency that primarily represents screenwriters, wanted a clear ad that would punch through the clutter. Designer Sean Adams says that his firm tied the design into classic, international-style work done for the entertainment industry after World War II. Because the client's work is all about words, an all-type ad made sense. A three-day turnaround also made the approach more practical.

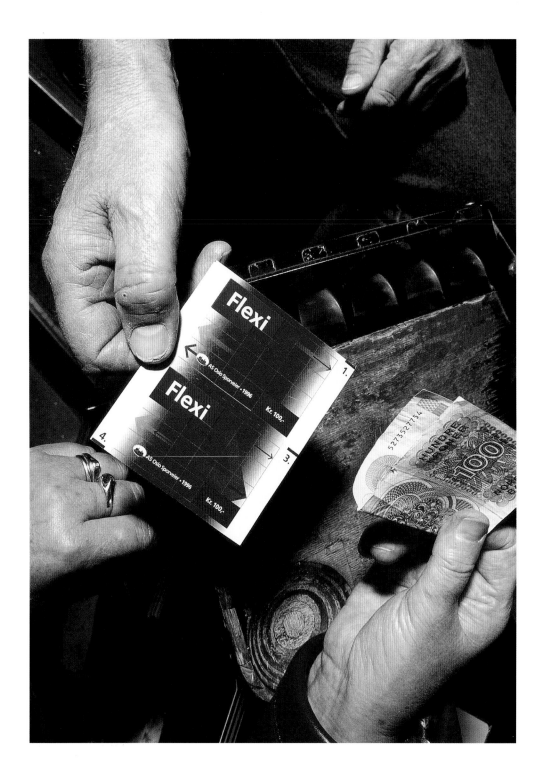

design firm Ashley Booth Design

designer Ashley Booth

As Oslo Sporveier Flexi-Pass ■ Because it is a secure document that might fall prey to counterfeiters, this transport ticket for the Oslo transport system carries a complex series of safeguards in its design. But designer Ashley Booth distracts the eye from more utilitarian elements by using bold colors and simple graphics. Other tickets carry other colors but similar graphics.

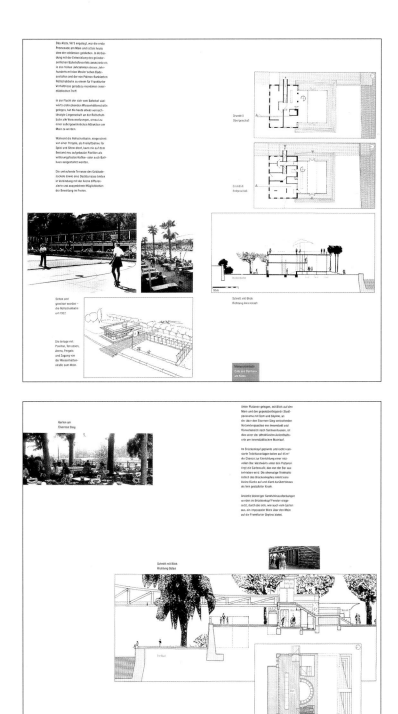

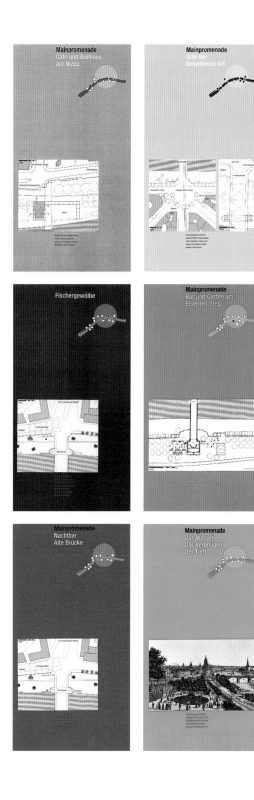

design firm Büro Für Gestaltung

designers Christoph Burkardt, Albrecht Hotz

Herausgeber Und Bezug Mainpromenade Maps ■ The Mainpromenade are the avenues on both sides of the Main River that flows through the center of Frankfurt. These vibrant maps were created for investors, who use them to find existing spaces on the Promenade and to consider how they might be turned into bars, cafés, galleries, and so on. All recipients receive the lighter blue map, but the other maps are organized into packets that are customized to each investor's interests. Each color interacts well with every other color and conveys the energy and excitement of the redevelopment project.

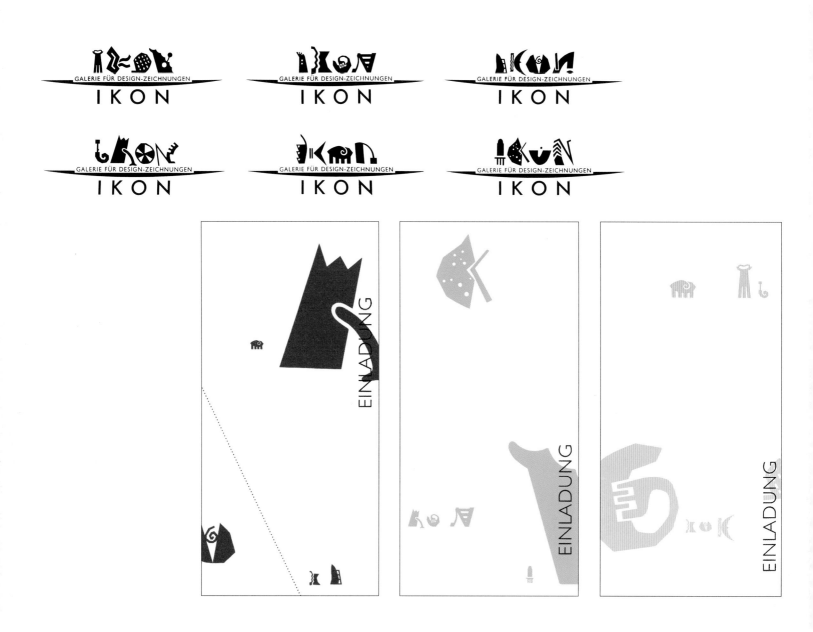

design firm Büro Für Gestaltung

designers Bettina Burkardt, Albrecht Holz

Ikon Gallery Logos ■ The IKON gallery specializes in showing design drawings, not the often well-known finished products that emerge from the plans. Designers at the Büro Für Gestaltung felt that a raw identity for the gallery would provide plenty of interpretations and convey the unfinished nature of the work it shows. A host of similar but different logos were designed, each filled with charming, doodle-like characters at top. The characters reappear on brochures announcing shows and the like, reproduced in bright palettes of coordinating colors.

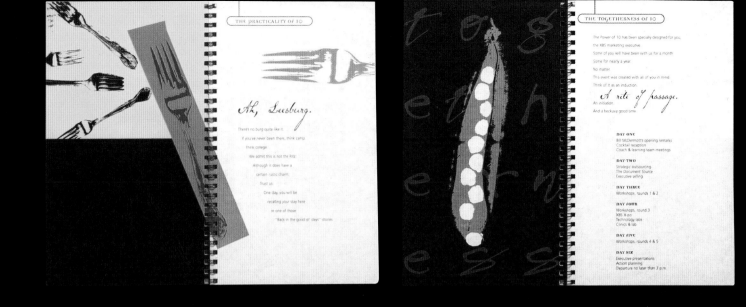

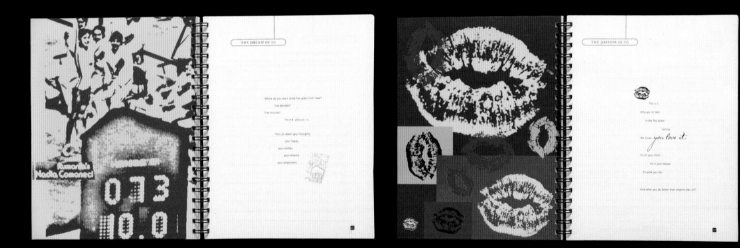

design firm Buck & Pulleyn

creative director Chris Lyons

art director Diane Fitzgerald Harris

copywriter Kate Sonnick

Xerox Business Services Books ■ Produced for the Xerox Business Services Training Program to promote its mandatory ten-step selling process, these books were designed to make attendees feel special and enthusiastic. Xerox's mandate to designers at Buck & Pulleyn was to produce the entire piece on Xerox equipment. The designers took the challenge one step further: They created vibrant artwork, too, photocopying real objects—pea pods, hands, sunflowers—and colorizing them à la Andy Warhol.

the

i

of the

storm

TSI International Software 1997 Annual Report

content
vs
plumbing

What makes application integration so hard? With all the technology around to connect one system with another, you'd think it would be easy... There are message queuing systems. File transfer programs. Database access software. The list goes on. ■ But simply connecting applications isn't the issue. Software that connects applications is like plumbing. Real value is in the information going through pipes. Something plumbers really don't know much about. ■ That's where TSI's Mercator comes in. It solves by far the hardest part of the problem. It fully integrates the actual content of applications. And it does it for applications of any type, running on any computer system. Applications that never even knew the other existed. And without having to write programs. Which means big savings in time and money. ■ Productivity gains using Mercator can be substantial. In fact, savings of 80% and more compared to programming are not uncommon. Which is not surprising. As Gartner Group says, "Only 5% of the interface is a function of the middleware choice. The remaining 95% is a function of application semantics." Simply put, the most costly part of integration is the transformation of application content from the unique data formats of one system to those of another. ■ With the plumbing becoming a commodity, the value of Mercator will only increase. And it doesn't make any difference what kind of plumbing is used. Mercator works with just about any software or middleware tool you can name for transporting data.

design firm	SVP Partners, formerly of Meyer Design Associates
design director	Jean Page
designer	Randy Smith
printing	Daniels Printing Co.

TSI International Software Annual Report ■ SVP Partners' charge in creating TSI's 1997 annual report was to position its client as the leader in application integration software, a chaotic and somewhat undefined market. The firm's response put its client in the "*i*" of the storm, so to speak. SVP picked up on the red and blue *i* in the company's logo and built all of the report's art around it, simultaneously playing with the type and message. The addition of a brilliant green effectively accents the other colors and gives the report a dramatic, memorable punch of excitement.

color folder

design firm	Larsen Design + Interactive
creative director	Tim Larsen
art director	David Shultz
designer	John Ferris
Illustrator	Craig Frasier
printing	Challenge Printing

black folder

design firm	Larsen Design + Interactive
creative director	Paul Wharton
art director	Sascha Boecker
printing	McIntosh Embossing

Imation Folders ■ Larsen Interactive created two very different folders for Imation, for two very different audiences. The target for the vibrantly colored design was corporate outside-service buyers of Imation's technical-support services, people who would not normally receive materials that are so bold and simple. Imation's corporate standard is built around bold color, so the folder identified the company immediately. The black folder, just as dramatic in its lack of exterior color, was for an elite audience of Fortune 500 corporate officers. Three key symbols are used in equal measure across the entire surface of the folder. The embossing die was one of the largest and most complex the embossing company had ever created.

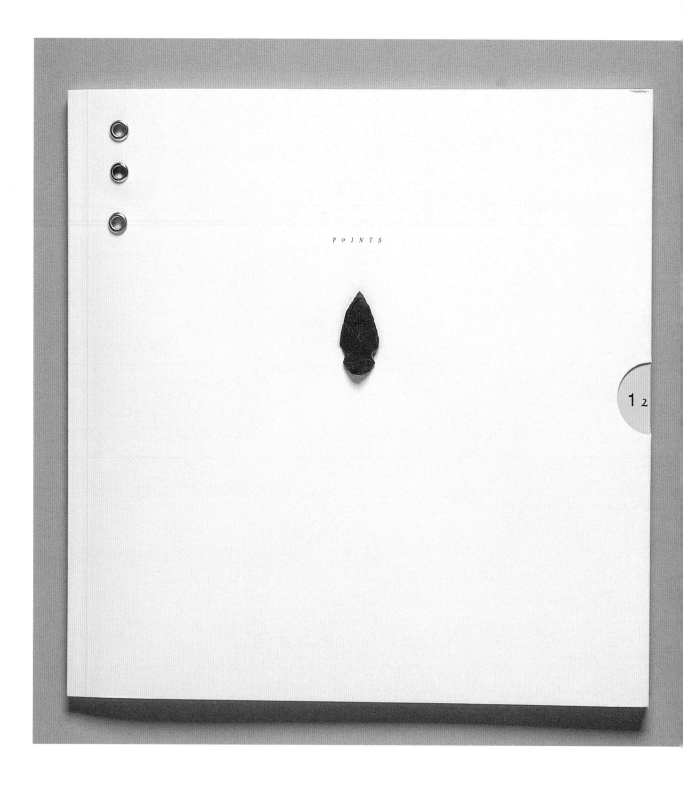

POINTS

1 2

design firm Slaughter Hanson
designer Marion English Powers
photographer Don Harbor

Boy Scouts of America Annual Report ■ The Boy Scouts of America uses its annual report as a primary vehicle for external communications all year long. The books are designed to raise awareness among corporate leaders and to help stimulate contributions. The 1997 annual report, designed by Slaughter Hanson, used a very bold, direct approach: Vibrant, flat colors in geometric shapes play against emotive black-and-white photos of boys involved in scouting. The theme of "points" is carried throughout the book, as the twelve points of Scout law are illustrated. An arrowhead—a tangible point—is glued right onto the front cover.

2. type

Type is ubiquitous today—in print, on the Internet, even on clothing. We cannot escape it. Type almost has become the wallpaper of our world. ■ But when a designer takes a word or two, or even a letter, sets it outside of the grayness of endless text, and treats it in a new way, the effect can be dramatic. Minimal type liberates the literate brain. It arrests the eye. Words or letters become art with messages that exceed their conventional meanings. ■ With minimal type, the designer can convey an astoundingly clear message. The viewer finally can focus on the dark bottom of the well of words and understand. As Robert Frost wrote, "For once, then, something."

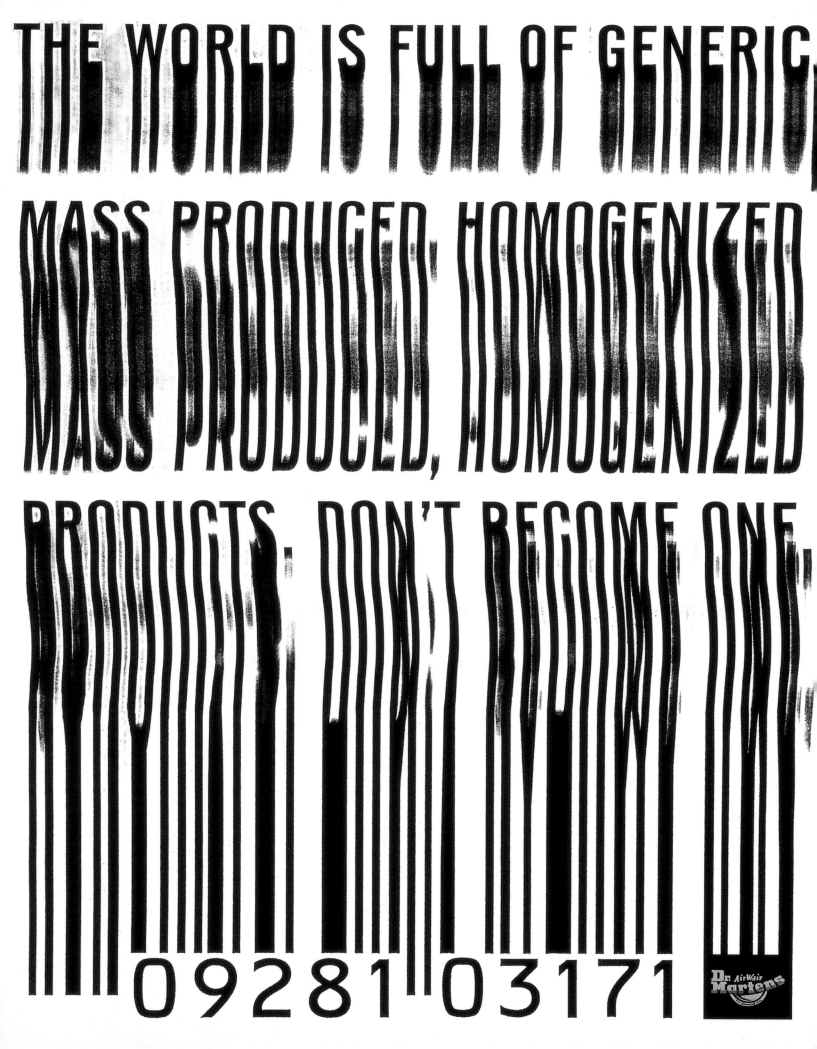

THE WORLD IS FULL OF GENERIC MASS PRODUCED, HOMOGENIZED PRODUCTS. DON'T BECOME ONE.

09281 03171

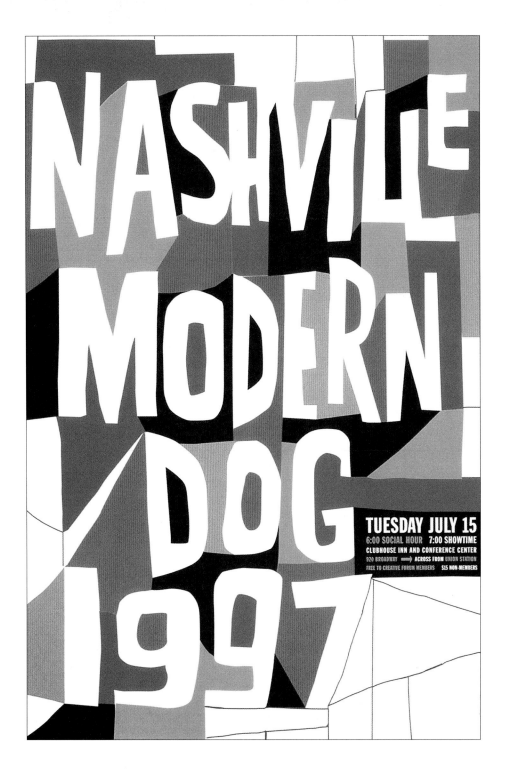

design firm Modern Dog
art director Vittorio Costarella
designer Vittorio Costarella
illustrator Vittorio Costarella

Nashville Creative Forum Ad ■ Sometimes a fundamental approach most strongly affects a sophisticated audience.
Designer Vittorio Costarella of Modern Dog had admired a 1950s-type pattern shortly before he was called on to create
a poster/mailer that would advertise a presentation his firm would give to the Nashville Creative Forum. He let the pattern
resurface in the design, allowing its flat, blocky colors to define hand-rendered letters. The type says "modern," literally
and stylistically.

Jay Czerkadden Graphic Design

j a y

2121 western ave. #204 seattle. WA 08121

Jay Czerkadden Graphic Design

j a y

j a y

2121 western ave. #204 seattle. WA 98121 P 206 284 1340 F 206 284 5079

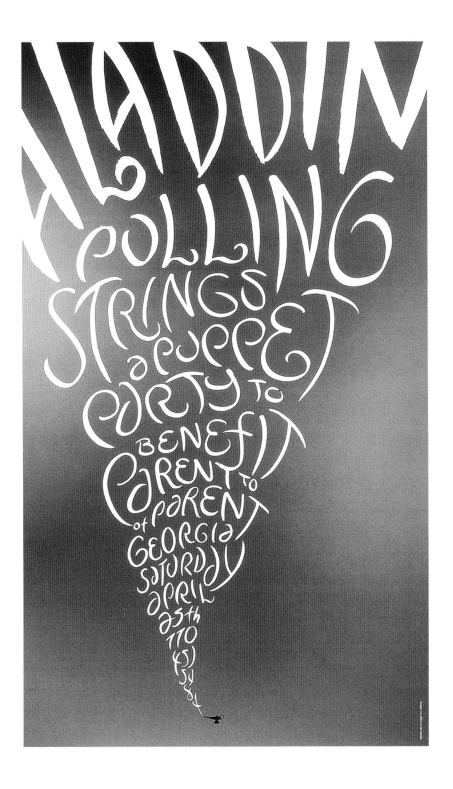

design firm Office of Ted Fabella

designer Ted Fabella

Parent to Parent of Georgia Aladdin Performance Promotion ■ Each year, The Center for Puppetry Arts holds a special benefit performance for Parent to Parent of Georgia, a nonprofit organization that raises money for families of children with special health-care needs. In 1998, the puppet performance was Aladdin, and a Middle Eastern–flavored party followed it. For a poster/mailer to promote the event, Ted Fabella wanted to avoid using a conventional genie image, but he decided to use the legendary lamp, greatly downplayed. The main feature is the type, hand-rendered with a brush to suggest smoke and Islamic writing simultaneously.

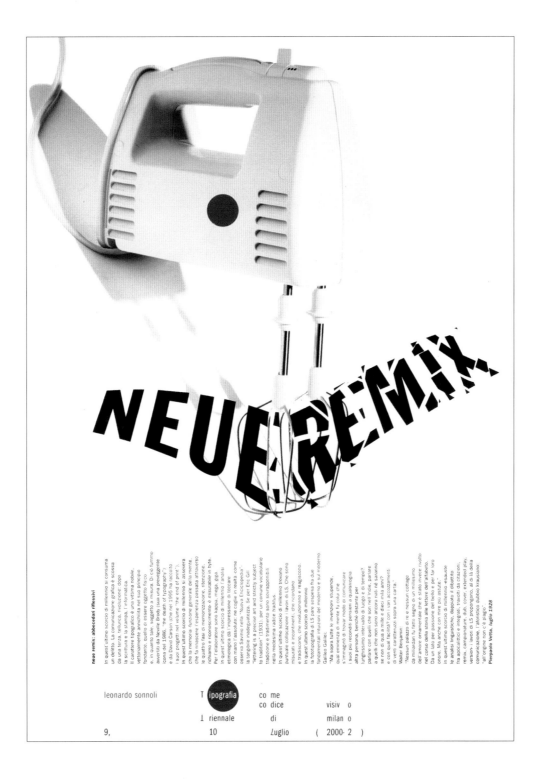

design firm Studio Dolcini Associati

art director Leonardo Sonnoli

designer Leonardo Sonnoli

illustrators Pierpaolo Vetta, Leonardo Sonnoli

Electric Mixer Poster ■ Leonardo Sonnoli created this poster to announce his own lecture at the Triennale of Milan. "Neue remix" was the title of the talk, referencing Jan Tschichold's 1928 classic, "Neue Typographie." Sonnoli spoke on the use of letters and words as things, and the use of things as words. This new level of "thingness" and "typeness," he says, is comparable to the way a disk jockey would consider music: They can be mixed and remixed in any way imaginable. The electric mixer, running through the lecture's title, was the perfect analogy (and it referenced Man Ray's picture of a manual mixer, titled *Man*).

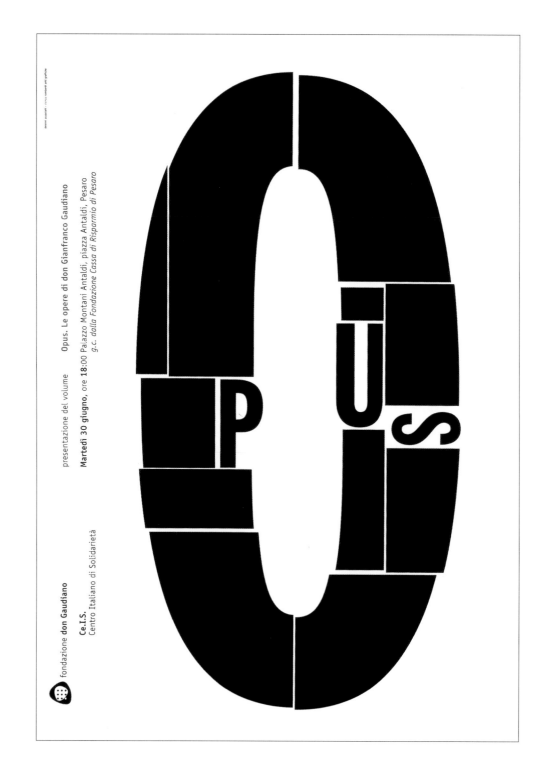

design firm Studio Dolcini Associati
designer Leonardo Sonnoli
copywriter Leonardo Sonnoli

Fondazione Don Gaudiano Opus Poster ■ Fondazione Don Gaudiano is a nonprofit foundation created by a Catholic priest who supports the homeless, people with AIDS, disabled persons, and other people who need extra help to live. Designer Leonardo Sonnoli created this poster to advertise an event that would present a book titled *Opus*, which detailed all of the good works the foundation has undertaken. The many smaller pieces used to assemble the large graphic symbolize all of the little good deeds that together produce great things. The same graphic was used on the book cover and on invitations to the event.

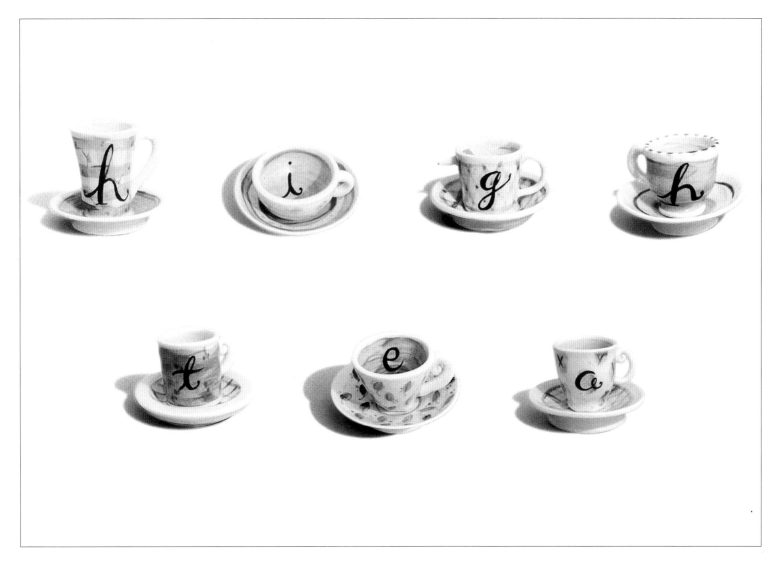

design firm	The Partnership
creative director	David Arnold
art director	David Arnold
designer	Anne-Davnes Dusenberry
illustrator	Anne-Davnes Dusenberry
photographer	David Arnold

International Multimedia Communications High Tea Invitation ■ The Partnership designers' natural interest and training in ceramics led them to an apt typographic solution for an invitation they created for client International Multimedia Communications, Inc. When this American company opened an office in London, it wanted a party invitation that illustrated its enthusiasm about joining another culture. David Arnold and Anne-Davnes Dusenberry crafted their own teacups for the design, glazing color and calligraphy directly on the cups. Each cup was photographed separately, then assembled electronically.

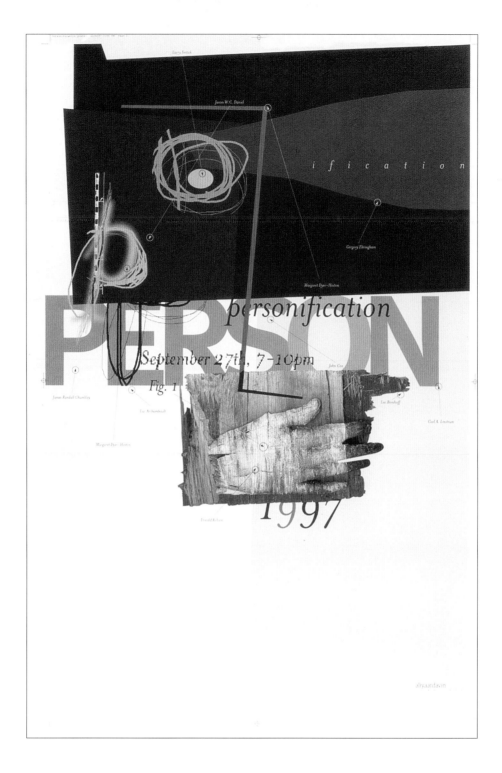

design firm	The Partnership
creative director	David Arnold
art director	David Arnold
designer	Anne-Davnes Dusenberry
illustrator	Anne-Davnes Dusenberry

Aliya Ardavin Gallery Personification Poster ■ This poster, advertising a gallery opening for an art show titled *Personification,* is simultaneously minimal and complex. Based on the work of various figurative artists, designers at The Partnership electronically assembled mixed-media creations like the papier-mâché hand to create a very abstracted human face. Each artist's name is called out, as in an anatomical illustration. Literally, according to creative director David Arnold, the artists represent valuable parts of the whole—by participating in the show—yet each is a valuable, individual part of the imagery.

Metro Atlanta YMCA 1996 Annual Report

8 9

How do we measure a year?

19
96

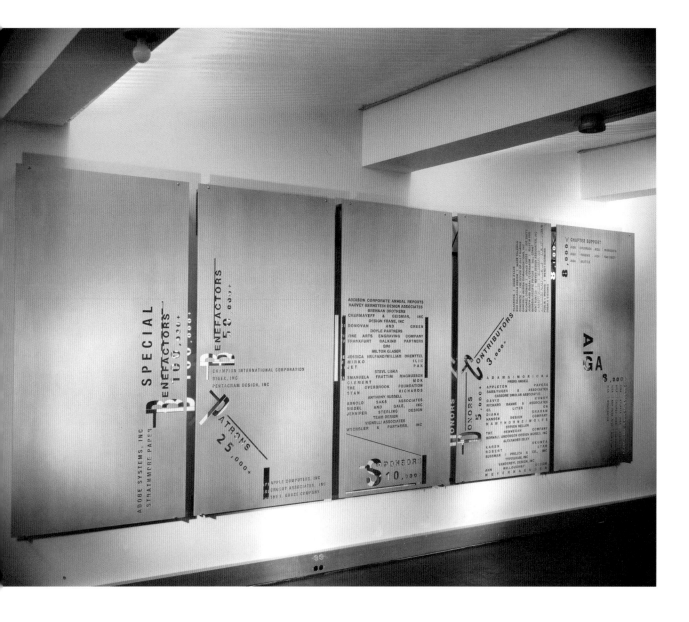

design firm Sterling Design
creative director Jennifer Sterling
designer Jennifer Sterling

AIGA Signage ■ This permanent installation at the American Institute for Graphic Art was created by Sterling Design to recognize special contributors to and benefactors of the organization. The bold metal panels, punched all the way through with type, make a multidimensional statement: Light passes through the panels and plays against the wall behind. Sterling's unusual grid, combined with flush-left and force-justified type, creates an intriguing visual statement from what could have been a dull listing of names.

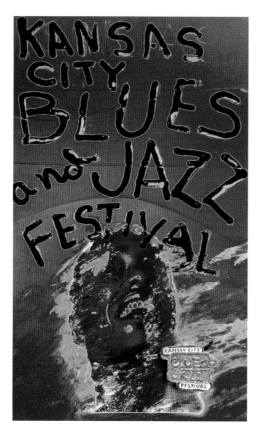

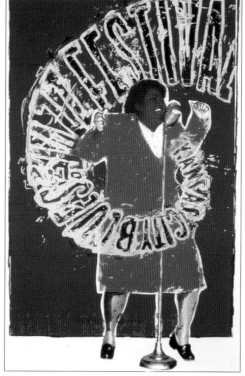

design firm Muller + Company
creative director John Muller
art director John Muller
designers John Muller, Jon Simonsen, Jason Bey

Kansas City Events Posters ■ Principal John Muller says that his design firm uses festival and performance event posters, like these extremely bold examples, as a way to experiment and play with type. All of this work was done by hand with materials such as globs and spatters of ink and paint, layered and scratched acetate, and torn paper. For Muller, it's like being a kid again. The spontaneity of the designs contributes to the excitement of the events themselves. The obviously hand-done origins render more direct, personal art than possible with an electronically rendered design.

design firm Jon Flaming Design
creative director Georgia Christensen
art directors Clay Freeman, Jon Flaming
designer Jon Flaming

Neiman Marcus Stats Logo ■ Sports bar STATS at Neiman Marcus opened specifically to celebrate the store's ninetieth anniversary. Because Neiman Marcus is recognized for its simplicity and clean lines in design, the bar's logo required the same treatment. In fact, it was only used in black and white. Squared-off letterforms, blocks of black and white, and the use of plus signs/crosshairs as substitute *T*s create a very minimal, spare, recognizable identity.

THOMAS BORKOVEC
ROBBIE McCAULEY
DAN COLLINS
JONATHAS SANTOS
MARK LEANOVOV
JACK RISLEY
CHARLES GAROIAN
THOMAS MULREADY
GERRY ORMISH
MATTHEW GOULISH
LIN HIXSON
ALLAN KAPROW
HENRY SAYRE
JOANNA FRUEH
ANN LANGSBACH
STEVE DURLAND
ANNE MARSH
CARL LEGGE
JEFF McMAHON
ROGER SHIMOMURA
TIM MILLER
JEANNIE PEARLMAN
MARK ALLEN
KENNETH FOSTER
RACHEL ROSENTHAL
SUZANNE LACY
MOIRA ROTH
THOMAS RULLER
MARILYN SANDFORD
KRISTINE STILES
KEN THOMPSON
MARIA DeMEDYS
JOHN WHITE
JAMES LUNA
MARTHA WILSON
ROBERTO SIFUENTES

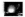

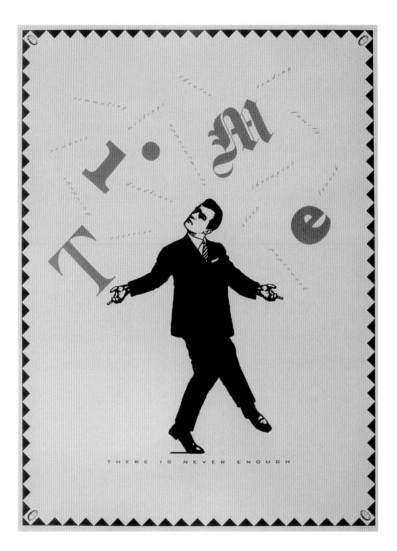

THERE IS NEVER ENOUGH

design firm Scorsone/Drueding

designers Joe Scorsone, Alice Drueding

Scorsone/Drueding Self-Promotion ■ Joe Scorsone and Alice Drueding say they suffer from twentieth-century maladies common to many today—guilt, self-doubt, fear, pressure, and lack of time. Luckily, they also have a sense of humor. They turned their troubles into a series of six 22-by-30-inch promotions (three shown here). Recipients are sent the print that designers feel fits him or her best. The ability to communicate with clients in such a personal, empathetic way while sharing their minimal design aesthetic created a very effective self-promotion.

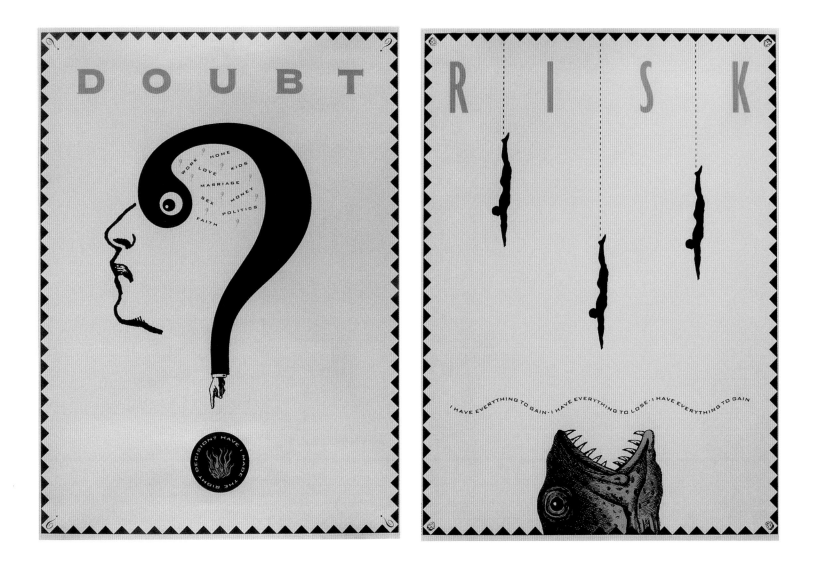

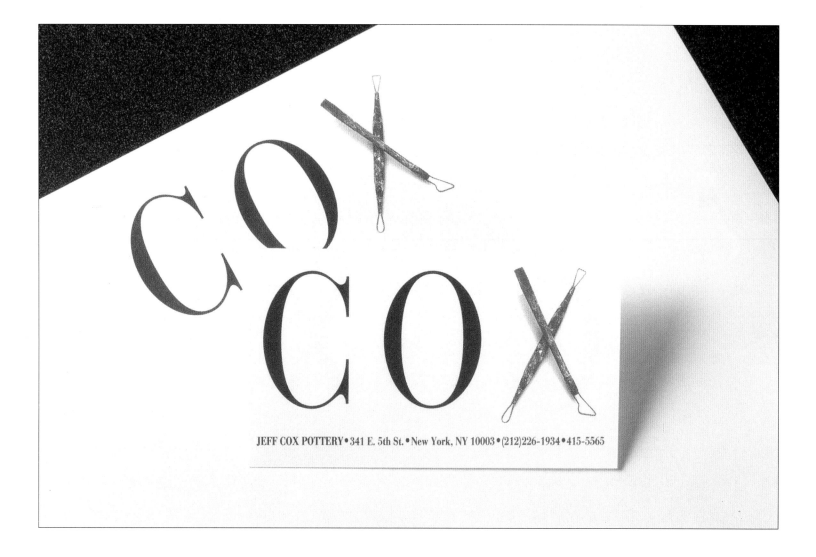

design firm Frank Baseman Design
designer Frank Baseman

Cox Stationery ■ Working with a name as short and sweet as Cox, designer Frank Baseman felt sure he could provide his ceramic-artist client with a typographic solution. The answer emerged as he considered his client's tools of the trade: Crossed ceramics tools simultaneously formed an *X* and explained what the client did.

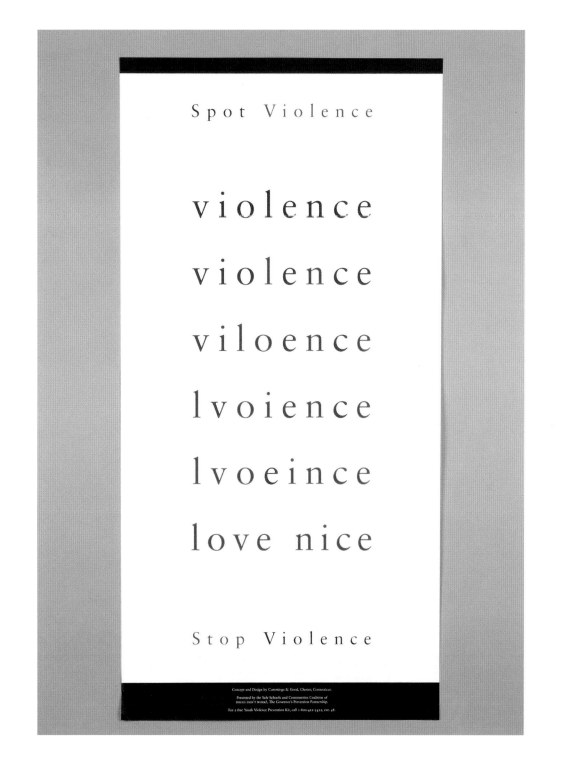

design firm Cummings & Good
designer Chris Hyde

Drugs Don't Work Love, Nice, Violence Awareness Promotion ■ Designer Chris Hyde says the design for this poster that promotes Violence Awareness month actually began with the word *violence*. Immediately, he saw the letters *l, o, v,* and *e*. After cutting those letters from the original word, the word *nice* remained. The design developed quickly from there and was supplemented with the anagrams *spot* and *stop* at the top and bottom of the poster.

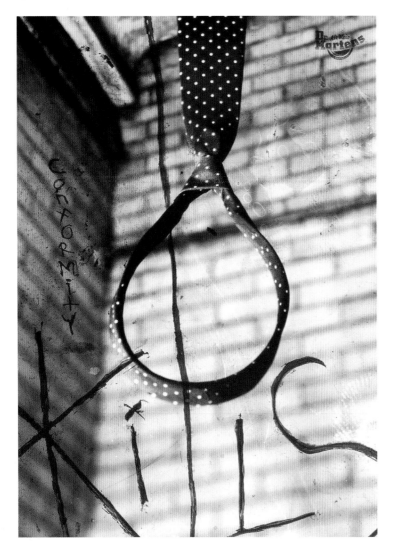

design firm PYRO
designer Eric Tilford
copywriter Todd Tilford
photographer James Schwartz

Dr. Martens Print Ads and Posters ■ The threat of conformity, group-think, and crowd mentality surround us every day, these Dr. Martens print ads and posters declare. Ironically, Dr. Martens products, once the domain of freethinkers everywhere, have now become part of the uniform for young adults and teenagers—they have become part of the mainstream. These posters and print ads were meant to warn the very people who wear the company's products, that individualism is still the best way.

a···

Annette Ernst

Sprecherin
Moderatorin

T 069. 56 02 03 12
F 069. 56 02 03 13
T 0171. 530 02 45
NADFILM@aol.com

Wolfsgangstrasse 76
60322 Frankfurt / M.

a···

Annette Ernst

T 069. 56 02 03 12
F 069. 56 02 03 13
T 0171. 530 02 45
NADFILM@aol.com

Wolfsgangstrasse 76
60322 Frankfurt / M.

herzliche Grüsse.

···

DIANE FITZGERALD HARRIS

artdirector.

170 FERNBORO ROAD ROCHESTER NY 14618

716.244.9282 FITZHA@EZNET.NET

designer Diane Fitzgerald Harris

Art Director Business Card ■ Diane Fitzgerald Harris' business card pretty much says it all: No fluff. Harris didn't want one of those cards that are so busy that the recipient doesn't know where to look. The colors she chose are a slight variation on primary brights, shades that Harris felt were earthy and easy on the eye.

design firm	Palmer Jarvis DDB
creative director	Chris Staples
art director	Daryl Gardiner
copywriter	Miles Markovic

Palmer Jarvis UPC Ad ■ If this design were any more minimal, it wouldn't be here at all. Design firm Palmer Jarvis DDS uses it as an advertisement in ad-industry publications to suggest subtly to marketing professions and potential clients that the firm has broken out of the forms for typical creative thinking. Sometimes, Palmer Jarvis uses the misshapen UPC by itself as a mark on collateral and presentation materials.

design firm Dogstar

designer Rodney Davidson

Cigar Aficionado Logo ∎ When Rodney Davidson submitted his first logo sketches to the art director of *Cigar Aficionado* magazine, they were very illustrative and complex. The art director liked the work, but he asked for something simpler. Davidson's second round of sketches began with some marker doodles. He tried to capture a cigar smoker with just a few strokes. Immediately, he could see that a *C* and *A* could be used to create a simple outline of a cigar lover wearing a fedora. Davidson says he often meets with such accidental successes by drawing the same image over and over again, with slight variations each time, until something unexpected and serendipitous emerges.

design firm Art 270, Inc.
designer Carl Mill

Interconnect Logo ■ Interconnect is a designer and manufacturer of computer connection devices, including connectors, plugs, and wires. Designer Carl Mill hit upon a logo solution for the firm almost immediately: He connected the dot to the body of the *i* with a standard pin system.

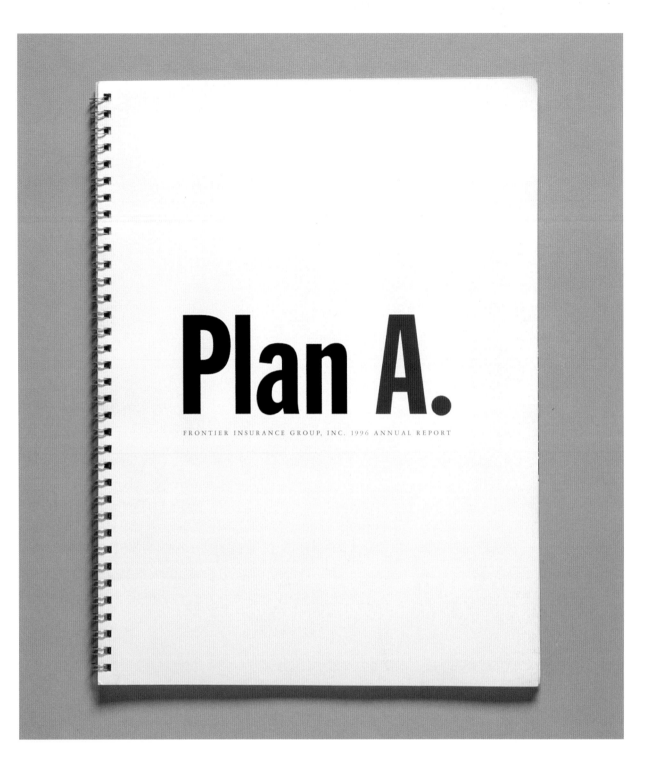

design firm SVP Partners, formerly of Meyer Design Associates
design director Jean Page
designer Robert Vitale
copywriter Colin Goedecke
printing Daniels Printing

Frontier Insurance Group Annual Report ■ Frontier Insurance Group insures high-risk clients, including white-water rafters, sky divers, and physicians (for malpractice). The firm constantly works to identify new markets—Plan A—and to become their leader in it—Plan B. SVP Partners built around the "plan" plan, constructing typographic plays-on-words that highlighted six key areas of excellence within the company. Initially, the client asked for pictures of sky divers, rafters, and doctors: SVP convinced Frontier that such images only showed who they insured. Instead, the firm should explain what they do and how they do it well.

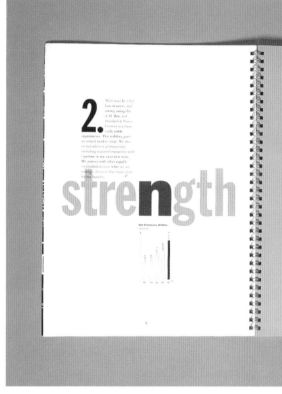

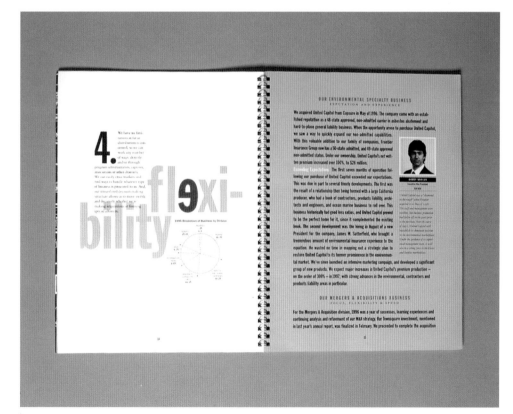

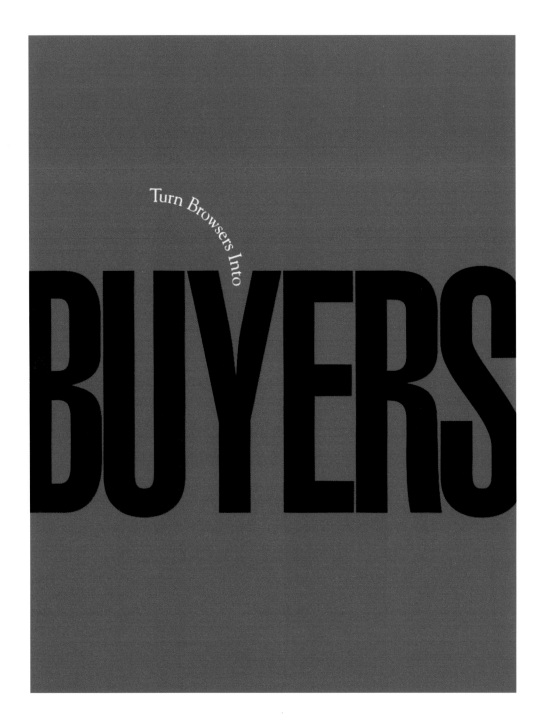

Turn Browsers Into

BUYERS

design firm	Brian J. Ganton & Associates
art director	Brian J. Ganton Jr.
designers	Mark Ganton, Christopher Ganton
photographer	Christopher Ganton

Calico Cottage Turn Browsers Into Buyers Book ■ Calico Cottage offers retailers a sweet deal: the opportunity to make and sell fresh fudge in their shops and in doing so, increase overall sales. The firm wanted to create a brochure that took a bold, direct approach to reaching retail storeowners. To accomplish this, designers at Brian J. Ganton & Associates created a cover that stated store owners' fondest wish—and they did it in a bold, direct way. The charming curved line of type points directly to the goal—buyers—playing across a background color that is impossible to ignore.

design firm	Henderson Tyner Art Company
creative director	Troy Tyner
designer	Troy Tyner
copywriters	Cheryl Swam, Mike Fox
photographers	Alex Bee, Kevin Lee

Reynolds Carolina Federal Credit Union Simple Annual Report ■ The objective of Henderson Tyner Art Company's client for this annual report was to communicate how the company can simplify members' lives through their products and services. The design firm felt that the best way to communicate *simple* was to create a non-design cover with the same impact as an image-heavy cover. White on white was a tough sell, reports creative director Troy Tyner, but the blind deboss gave the cover a tactile quality and approachable tone the client wanted.

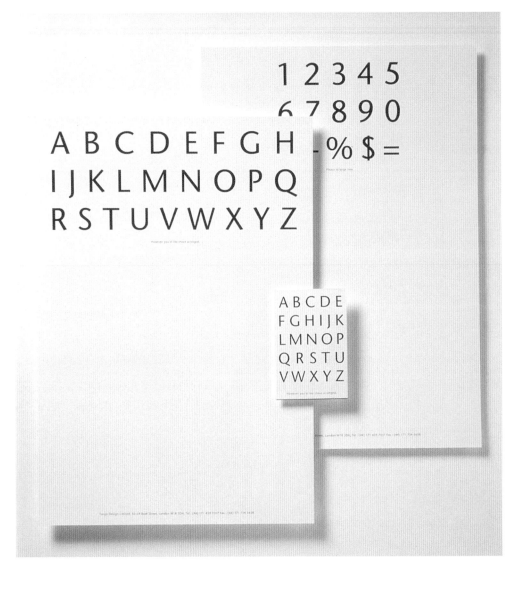

design firm Tango Design Ltd.
creative director Peter Rae
designer Peter Rae

Becky Rae Copywriter Stationery ■ The brief for creating a stationery system for a copywriter stressed the need for a design that visually reflected the creative nature of her work. Because words and letters are tools of her trade, it seemed appropriate for Tango designers to use those as visuals. The effect is not only simple and attractive, it also is almost an advertisement for the client and her sense of humor, as the invoice sheet shows.

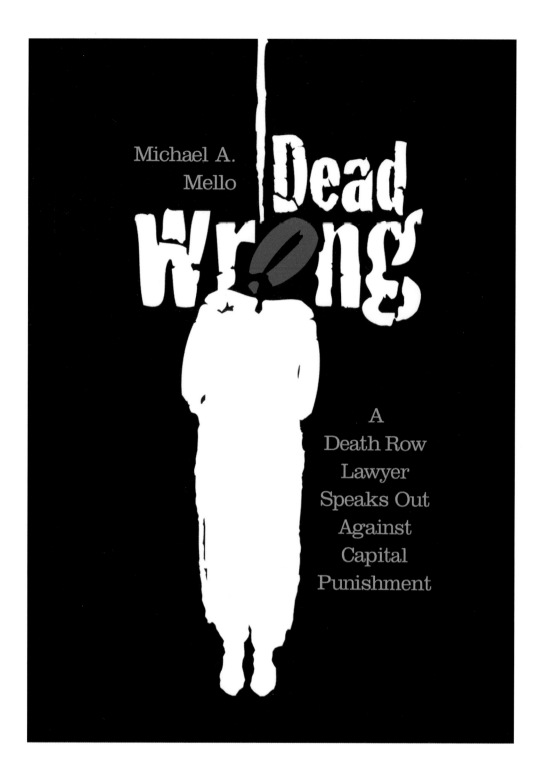

Michael A. Mello

Dead Wrong

A Death Row Lawyer Speaks Out Against Capital Punishment

design firm Toolbox, now Consolidated Graphics & FIREPOWER Design Co.

designer Mark Macaulay

illustrator Mark Macaulay

University of Wisconsin Press Dead Wrong Cover ■ Designer Mark Macaulay had a tough design problem in front of him: Create a powerful cover for a book on the death penalty with only two colors and $600. To find his solution, he began thinking of the contrasts between right and wrong, life and death, black and white. His dramatic illustration of the dead body as part of the title shakes the nerves a bit and underlines the author's provocative argument.

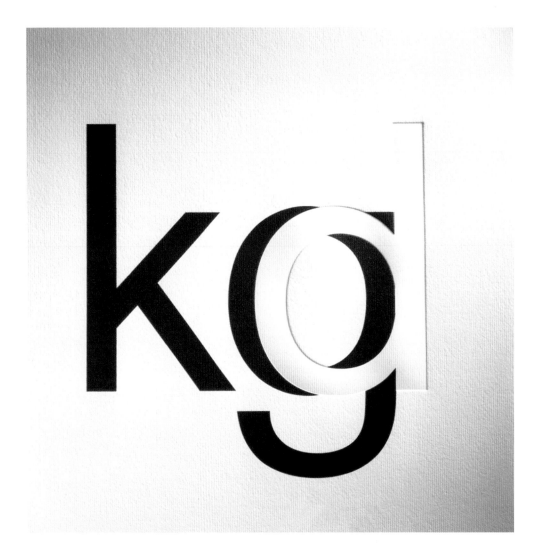

design firm Lippa Pearce Design, Ltd.
art director Harry Pearce
designer Harry Pearce

Kenneth Grange Design Identity ■ Following his retirement from Pentagram, of which he was a founding partner, Kenneth Grange opened a new office, Kenneth Grange Design. Lippa Pearce Design, Ltd. created a timeless mark for the designer that spoke of the simplicity, clarity, and purity associated with his work. At first sight, the symbol appears to be a two-dimensional solution made from the letters *k* and *g*. On closer inspection, *d* appears as part of the *g*. This is embossed and gives of the *g* giving it a three-dimensional quality.

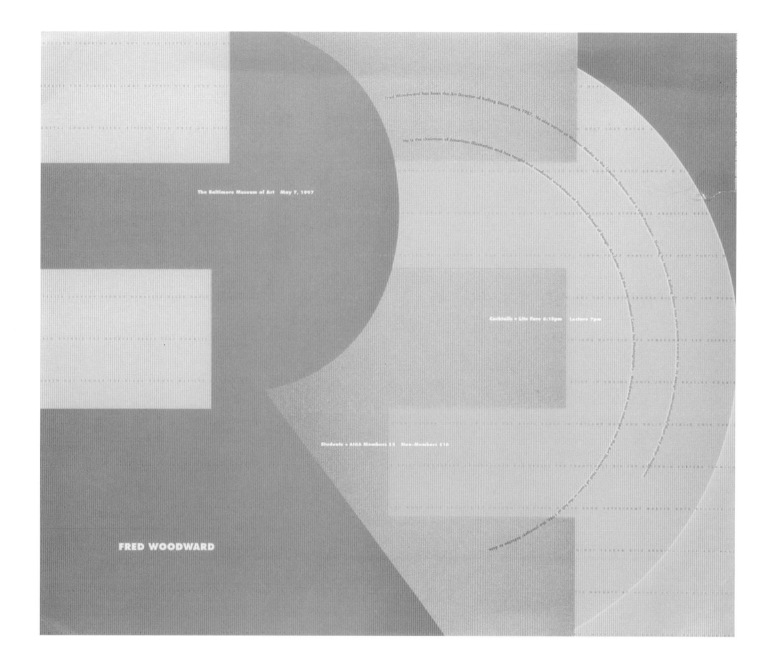

The Baltimore Museum of Art May 7, 1997

FRED WOODWARD

Cocktails + Lite Fare 6:15pm Lecture 7pm

Students + AIGA Members $5 Non-Members $10

art director Jennifer Phillips
designers Jennifer Phillips, Dina Wasmer

AIGA Fred Woodward Announcement ■ To announce an AIGA-sponsored event at which *Rolling Stone* art director Fred Woodward would speak, designer Jennifer Phillips created a mailer that used only the most essential elements. Design circles don't include any other famous Freds, so she knew the name would deliver the message of "who." The symbol conveys the "what." Bold, bright colors allude to design; exciting typography invokes Woodward's own work with type; and the large green circle invokes the record albums or CDs of the music business.

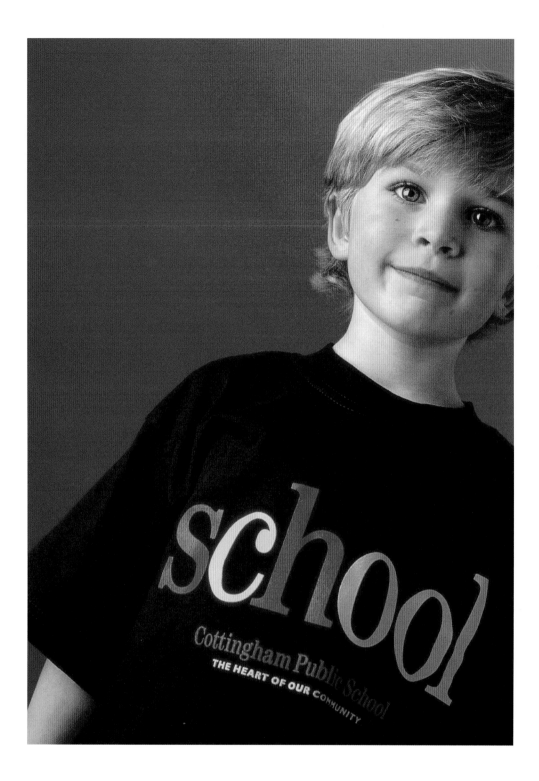

design firm HM&E, Inc.
designer Paul Haslip
printing The Edge

Cottingham Public School, Toronto, Cool School T-Shirt ■ This appealing T-shirt design initially was launched as a PTA project: The school wanted a shirt that children could wear to sporting events, concerts, and so on that would identify them as Cottingham students. But when the school was threatened with closure by the Toronto School Board because of financial cutbacks, the role of the shirt became much more important: They would be worn to rallies to protest the closure. A bold, highly readable design was mandatory. But now that the protests are over, the design still succeeds: Kids continue to wear them, even when they don't have to.

ARCHITECTURE WEEK

design firm Atelier Works
art director Quentin Newark
designer Glenn Howard
typographer Alan Kitching, Typography Workshop

Arts Council of England Architecture Logo ■ When the Arts Council of England's architecture department launched a new initiative called Architecture Week to distribute information to the public, it asked Atelier Works to create a logo. The group's brief read, in part, "Avoid favouring any one style or movement of architecture. It must be easy to use since it will be given to people who have never used a logo before—and make it look great!" The design firm's solution was to transform the word *architecture* into architecture—a skyline full of building of all sizes.

design firm Lisa Billard Design
designer Lisa Billard

Phoebe45 Materials ■ The partners of Phoebe45 wanted their new store to introduce a very select range of emerging fashion to Chicago, an area previously devoid of newer, lesser-known designers. The clothing would pay close attention to detail, in tailoring, color, and fabrics. Lisa Billard created an identity for the store that matched that same clean, modern feel, with the same deliberate use of color. All components created for the store—from stationery and business cards to hang tags and invitations to special events—have the same reserved, classic feel.

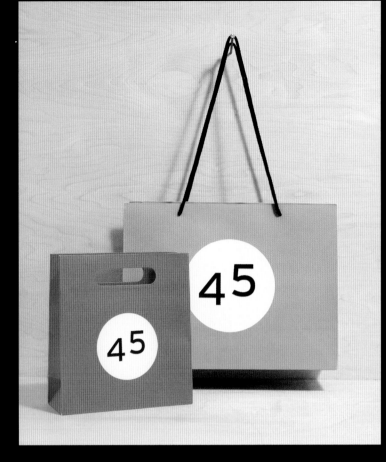

phoebe

phoebe

A grid by its very nature is a spare thing. What hangs on that grid, however, often muddies the water. ■ The designs in this section retain a Shaker-like purity that reveals a strict but not obsessive adherence to an underlying grid. Extending the Shaker metaphor, the designs have beauty and function, an unbeatable combination. Some actively promote recognition; others passively accommodate unpredictable content. ■ Maintaining the concept of "less" in a grid makes the designer work hard against the temptation to decorate. But when a carefully craft-ed grid successfully steers a design, the results let the communication flow.

3.
minimal grid

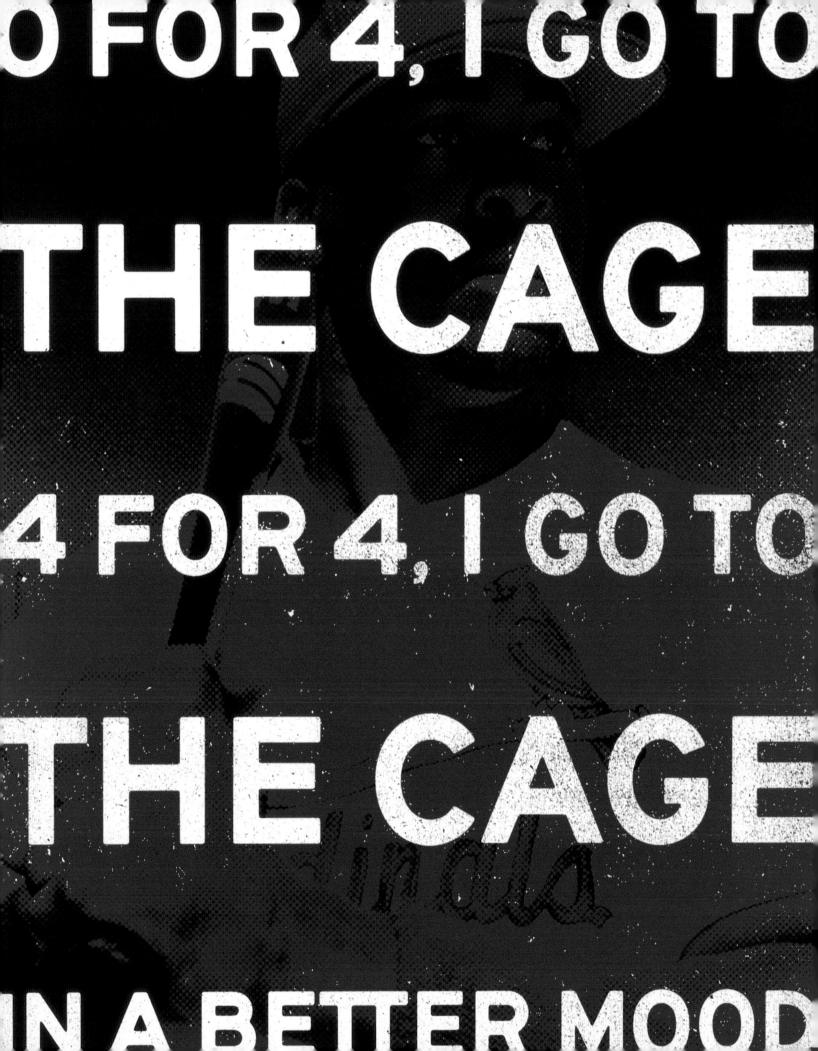

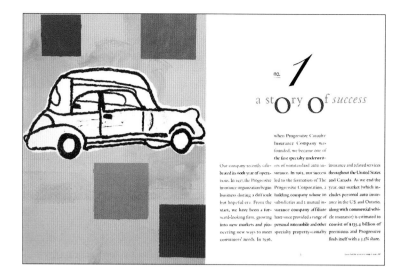

no. **1**

a st**O**ry **O**f *success*

when Progressive Casualty Insurance Company was founded, we became one of the first specialty underwrit-

Our company recently cele-
brated its 60th year of opera-
tions. In 1937, the Progressive
insurance organization began
business during a difficult
start, we have been a for-
ward-looking firm, growing
into new markets and pio-
neering new ways to meet
consumers' needs. In 1956,

ers of nonstandard auto in-
surance. In 1965, our success
led to the formation of The
Progressive Corporation, a
holding company whose sub-
sidiaries and 1 mutual in-
surance company affiliate
have since provided a range of
personal automobile and other
specialty property-casualty

insurance and related services
throughout the United States
and Canada. As we end the
year, our market (which in-
cludes personal auto insur-
ance in the U.S. and Ontario,
along with commercial vehi-
cle insurance) is estimated to
consist of $135.4 billion of
premiums and Progressive
finds itself with a 3.3% share.

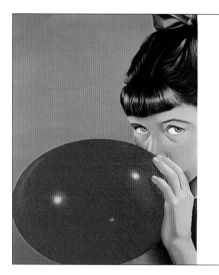

no. **5**

w h i r l w i n d

Question: When is a two-hour delay still
an immediate response? Answer: When a
tornado rips through your property and
the rest of your neighborhood. It took a
Progressive claim representative two hours
one Friday evening to navigate his way
through the debris and find the home of
one of our policyholders after a tornado

wrecked home in Smyrna, Tennessee. The
twister had lifted our policyholder's garage
high into the air and then very consider-
ately deposited it straight down onto his
pickup truck. Our claim representative
made his way to the scene, assessed the
damage and had a check in the policy-
holder's hand by the next business day.
Under the circumstances, we hesitate to
call our service a whirlwind, but we won't
sit at home waiting out the weather.

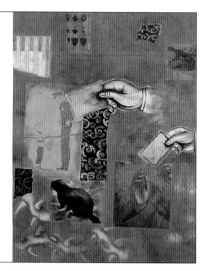

no. **8**

impressing a tr**OO**per

On his way home one evening, a Pro-
gressive claim representative hap-
pened upon a minor auto accident
involving one of our policyholders. As
he was inspecting the damage to the
vehicle, the police arrived. "Well I
guess since you're here, I can leave,"
joked one of the troopers. Later, the
trooper asked if the claim repre-
sentative wouldn't mind staying until
the police investigation was finished.

So our representative waited. What
did the trooper want? Just some in-
formation and a business card. He
was so impressed with our Immedi-
ate Response claims service that he
wanted to become a policyholder!

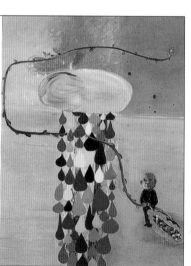

no. **10**

all y**O**u need *is* l**O**ve

When Donald Hoffman, an
independent insurance agent
writing for a competitor of
ours, heard that one of his
clients was badly injured in an
auto accident with a Progres-
sive policyholder, his heart
sank. Mr. Hoffman was in
Jackson, Michigan; his client
was vacationing near Daytona
Beach, Florida. There was
little he could do in person.
Yet he needn't have worried.
Progressive's Daytona Beach
claim representative Keith
Pelkey and office branch
manager Paul Lowe treated
Mr. Hoffman's client as if she

was one of our own. "The
compassion and concern they
showed were wonderful," says
Mr. Hoffman. "They even
came to the hospital to help
my customer." Donald Hoff-
man has since decided to end
his relationship with our
competitor and to begin rep-
resenting Progressive. In a
crisis, you can count on Pro-
gressive to be there.

design firm | Nesnadny + Schwartz
art directors | Mark Schwartz, Joyce Nesnadny
copywriters | Joyce Nesnadny, Michelle Moehler
artists | Various
copywriter | Peter B. Lewis

Progressive Corporation Annual Report ■ Nesnadny + Schwartz has designed The Progressive Corporation's annual report for sixteen years. In that time, the books have earned a reputation for their uniquely artistic approach. Specifically, Nesnadny + Schwartz designers work with fine artists to illustrate the themes of the various reports. Mark Schwartz says that what comes in always is a surprise because these are not people with commercial vocabularies. The books' grid is kept very simple and reactive to the art. The designers also responded with complementary type treatments that react to the rich illustrations.

design firm	Office of Eric Madsen
art director	Eric Madsen
designers	Eric Madsen, Amy Van Ert
copywriter	Words At Work
photographer	Terry Heffernan

Unisource Branch Out Brochure ■ Like all paper promotions, this one was created to demonstrate the product's performance and appearance. Unisource also wanted to show this paper's ability to excel in a wide variety of projects, from simple to complex, and from economical to high end. Brightness also needed to be stressed. To accomplish this, designers at the Office of Eric Madsen used items made from wood, starting with the source—a tree—and moving toward increasingly complex products. A very open layout allowed large areas of the paper to exhibit its brightness.

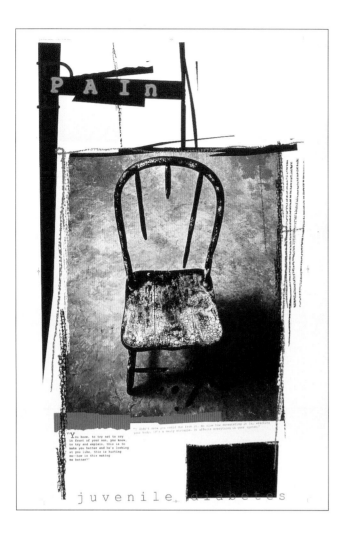

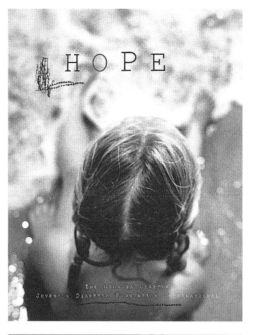

design firm The Partnership

creative director David Arnold

art director David Arnold

designer Anne-Davnes Dusenberry

copywriters Nancy Clark, John Hipp, Fred Glassbrook, David Arnold, Anne-Davnes Dusenberry

illustrator Anne-Davnes Dusenberry

photographers Tony Stone, Ibid.

Georgia JDFI Book and Poster ■ The Partnership created a truly powerful, emotional statement for the Georgia chapter of the Juvenile Diabetes Foundation International in an enlarged brochure and series of posters. Designers explored the big emotions that little children with diabetes might feel—anger, pain, fear, loneliness, and so on—and graphically represented them with rough crayon lines, red and black construction paper, and incredibly moving photography. Children who have diabetes stare back at the reader with expressions that share the realities of their lives and disease. The repeating grid allows readers to absorb the material quickly, yet it permitted the designers to change adeptly their treatment of type, line, and color.

design firm Sterling Design
creative director Jennifer Sterling
typography Jennifer Sterling
copywriter Tim Mullen
illustrator Jennifer Sterling
photographer Dave Magnusson

Pina Zangaro Catalogs ■ Jennifer Sterling's objective in designing these two Pina Zangaro catalogs was to create portfolios of work that reflected the client's design sensibilities. Much of Pina Zangaro's product line has a clean, fabricated look: Sterling mirrored the style. The spring 1996 catalog even has a cut-metal back cover, the same type of material used in many of the client's products. Each page of the catalogs has a clean, spare look, but many are overlaid with a printed vellum sheet, which adds another layer of graphics and interest without interfering with the information below.

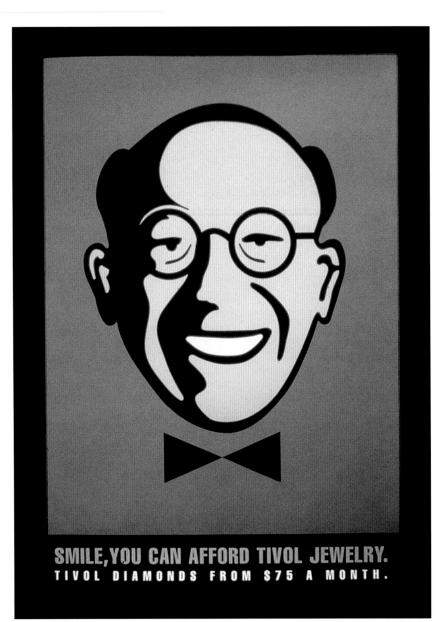

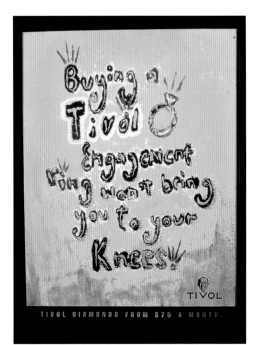

Tivol Jewels Promotion ■ These bold designs are two samples from a series created by Muller + Company to attract a younger audience to Tivol Jewels. They were used like subway posters, plastered on construction barricades and storefronts all over the city. The large head is a graphic rendition of the owner's likeness. The simple, direct approach very successfully created awareness of the client's offerings and affordability: Tivol enjoyed a 40 percent increase in patronage from its younger target audience.

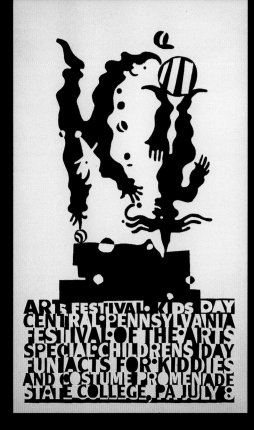
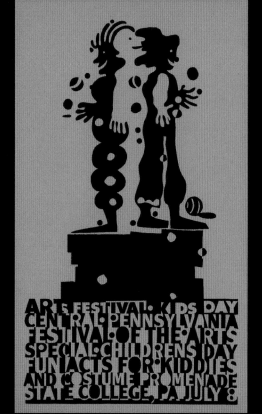
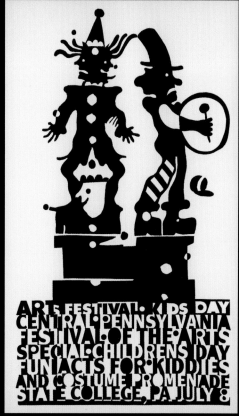

design firm Sommese Design
art director Lanny Sommese
designer Lanny Sommese
illustrator Lanny Sommese

Pennsylvania Festival of the Arts Kids Day Posters ■ Designer Lanny Sommese underlines the very formal grid he utilized for a series of four festival posters (three shown here) with identical, hand-rendered typography on each and a palette of related, brightly colored papers. Despite the formal arrangement, the effect is playful. The four posters had to relate as a series and not just for purposes of promoting the event: Many people collect Sommese's poster work and would display the four posters as a quartet.

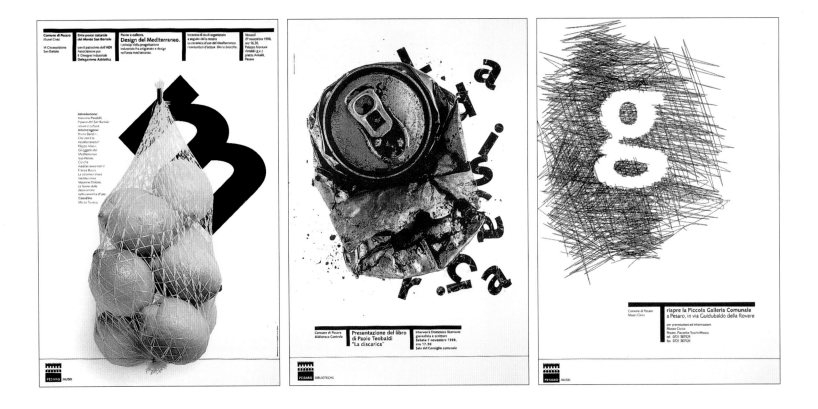

design firm Studio Dolcini Associati
designer Leonardo Sonnoli

Pesaro Musei Posters ■ For a series of posters created for cultural activities in the city of Pesaro, Italy, designer Leonardo Sonnoli designed a grid that would easily accommodate almost any type of imagery. (Only three entries from a more extensive line are shown here.) Displayed in public spaces and on walls around town, the posters' basic layout soon became recognizable: Viewers knew at a glance that this was an announcement of a worthwhile cultural event. The lemon poster was designed for a conference on Mediterranean design; the lemons can be loosely considered as a kind of packaging for a Mediterranean product. The smashed can design announced the presentation of a book titled, *La Discarica* (*The Dump*) about a man working in a dump. Finally, the scribbled *g* poster announced the opening of the "piccola galleria comunale" (the little gallery of the town). The "little gallery" was represented by the lowercase *g*; the background scribble symbolized all types of drawing.

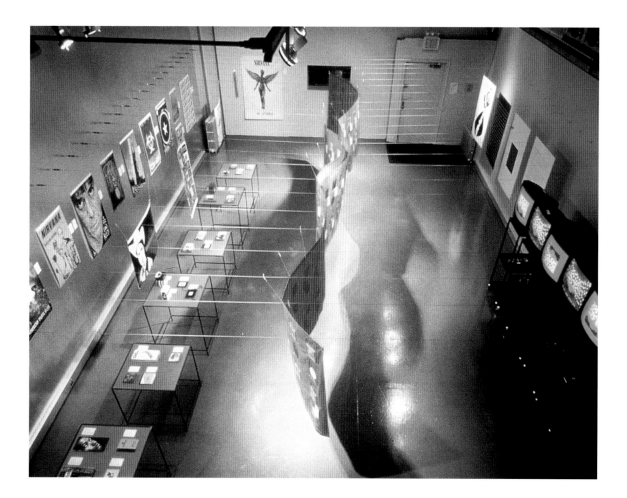

design firm AdamsMorioka

creative director Sean Adams

designers Sean Adams, Noreen Morioka, Anna Dolan

AIGA, Appleton Papers, Sound Off Installation ■ The AIGA *Sound Off* exhibition presented the 100 best CD covers from 1992 to 1997, together with books, advertising, and motion graphics, all created for the music industry. Designed as a traveling exhibition, the installation had to be self-contained, easy to mount in a variety of settings, and fairly theft-proof. Because they saw the music business is very changeable, liquid, and artificial, designers at AdamsMorioka created a floating exhibition. All 100 CDs are sewn into a vinyl shower curtain-like wall. The curtain can be easily rolled up, shipped, and then rehung at the next site. The posters and even the captions hung on the wall are encased in the same vinyl plastic.

1998

Januar · 2 · 3 · 4

Februar

März

April

Mai

Juni

Juli

August

September

Oktober

November

Dezember

Büro Für Gestaltung · Christoph Burkardt, Albrecht Hotz · Domstraße 81 · D-63067 Offenbach · T 069 88 14 34 · F 069 88 14 25

design firm Büro Für Gestaltung

designers Christoph Burkardt, Albrecht Hotz

Büro Für Gestaltung Calendar ■ Every year designers at Büro Für Gestaltung create a new year-at-a-glance calendar. But each year they challenge themselves to find a new way to structure 365 days, fifty-two weeks, and twelve months. The promotion/poster was the firm's 1998 effort, given away to clients as a New Year's greeting.

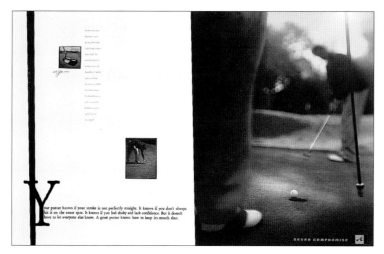

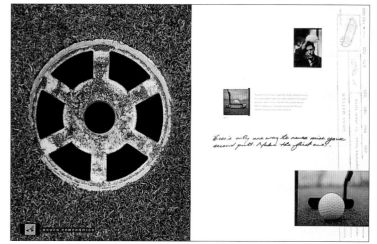

design firm CORE

art director Eric Tilford

copywriter Todd Mitchell

photographers Michael Eastman, Raymond Meeks

Never Compromise Golf Ads ■ Never Compromise is a young, aggressive golf company with a mission to serve as an advocate for a more confident, precise style of putting. They push golfers to demand more of themselves and their equipment, as this series of simple, bold ads shows. Targeted at the 5.5 million avid golfers in the United States—compared with the total U.S. golfer population of 25 million—the ads ran in all of the leading golfing magazines.

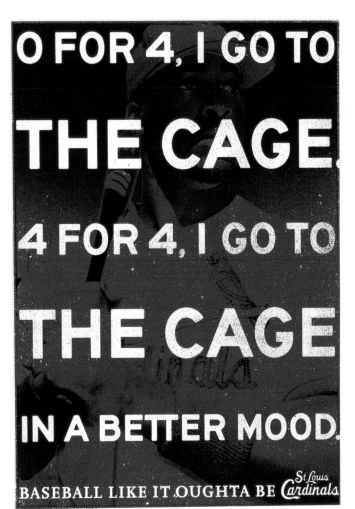

O FOR 4, I GO TO **THE CAGE.** 4 FOR 4, I GO TO **THE CAGE** IN A BETTER MOOD.

BASEBALL LIKE IT OUGHTA BE *St Louis Cardinals*

FOR TICKETS CALL 421-3060

#51 BELIEVES HE IS JUST ANOTHER PLAYER. THAT'S WHY HE IS NOT.

BASEBALL LIKE IT OUGHTA BE *St Louis Cardinals*

IT ONLY TAKES ONE SWING TO GET A HIT. IT TAKES 300 A DAY TO GET AN AT BAT.

BASEBALL LIKE IT OUGHTA BE *St Louis Cardinals*

FOR TICKETS CALL 421-3060

design firm FUSE
creative director Mike Franklin
art directors Mike Franklin, Mark Arnold, Bryan Rowles
copywriters Clifford Franklin, Dan Consigliano
photographer Jim Herren

St. Louis Cardinals Ads/Posters ■ These powerful designs, created by FUSE for the St. Louis Cardinals, were used as display posters, bus posters, billboards, and newspaper ads, and were meant to increase African-American attendance at Cardinal home games. The idea behind the "unproduced" photos was to strip away the glitter of sports superstardom and show that these are hardworking people who worked hard to get where they are. Forceful type superimposed on top of oversized images underlines the players' heroic stature. The campaign not only drew considerably more members of the target audience to the ballpark, the posters also became very popular collectibles: So many were taken home that FUSE faced a huge challenge to keep them posted.

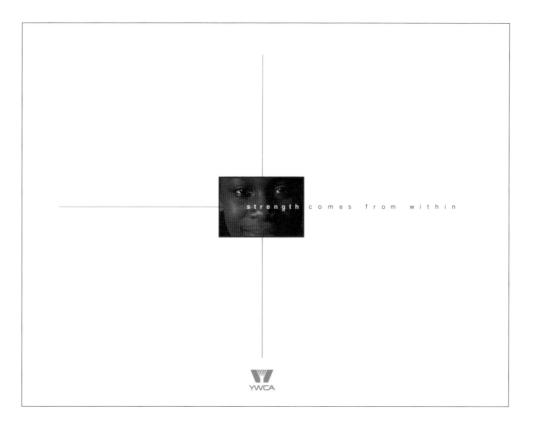

strength comes from within

YWCA

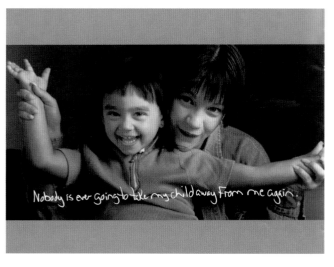

Nobody is ever going to take my child away from me again.

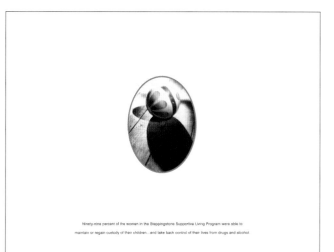

Ninety-nine percent of the women in the Steppingstone Supportive Living Program were able to maintain or regain custody of their children...and take back control of their lives from drugs and alcohol.

design firm	Buck & Pulleyn
creative director	Kate Sonnick
art director	Diane Fitzgerald Harris
copywriter	Kate Sonnick
photographer	Kurt Gardner/KSC

YWCA Report, Rochester and Monroe Counties ■ The strong, very simple design of this YWCA annual report was a backlash response against the thousands of Photoshopped images that surround us today, explains art director Diane Fitzgerald Harris. The book's theme, "Strength Comes from Within," called for a very honest, straightforward approach. Actual clients of the YWCA are pictured in the book; their dreams and personalities shine off the pages.

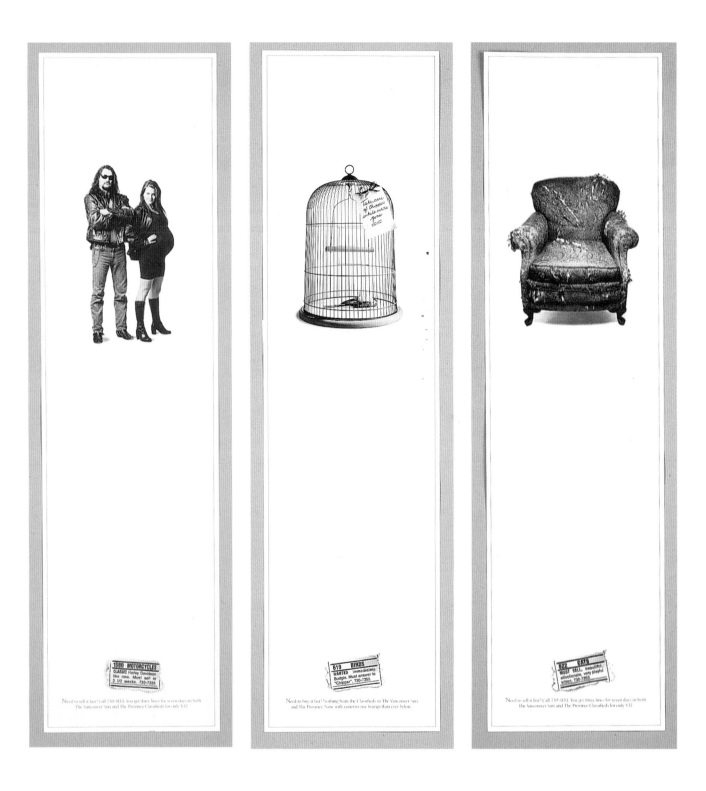

design firm Palmer Jarvis DDB
creative director Chris Staples
art director Dean Lee
copywriter Lesley Hazeldine

Pacific Press Ltd. Vancouver Sun Classified Ad Ads ■ Purposely built with plenty of white space to stand out on crowded classified ad pages, these ads tell stories as direct as they are amusing. Palmer Jarvis senior art director Dean Lee says the ideas for these three sprang from his own life: The motorcycle story is based on the sad but true saga of a friend. The bird ad speaks of the way he cares for his plants. If he explained where the idea for the chair ad came from, Lee says, his girlfriend would kill him.

WorkInProgress
The Joyce Foundation ● August 1997

Biotechnology: **Proceed with caution.**
Instead of spraying with pesticides,
farmers can now plant potatoes that are
poison to the potato beetle—but perfectly
safe in french fries. It's one of the mira-
cles of biotechnology. Enthusiasts call the
genetically engineered potato a victory
for farmers, consumers *and* the environ-
ment. Skeptics worry about unforeseen
problems in this brave new world. 6

WorkInProgress
The Joyce Foundation ● May 1998

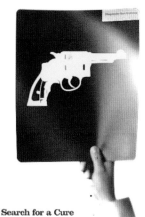

Search for a Cure
Homicide rates, especially in big cities,
are down. But in many small to mid-size
cities, murder rates are holding steady
or rising. One of America's leading
trauma surgeons wants to find out
what's going wrong and fix it. 11

RiskyBusiness

Farming is notoriously
risky. Farmers often turn to
pesticides to protect their
crops—and those pesticides
end up in our drinking water.
Jim Cubie has a better idea:
sell them insurance instead.

Wisconsin potato farmers are trying to do the right thing. The Wisconsin Potato and Vegetable Growers Association helps growers reduce their use of pesti-cides, which can contaminate nearby streams. The group has developed finely-tuned tests that enable farmers to spray only when and where they need to. But Dean Zuleger, head of the growers' group, says his members face a tough sell when they try to bor-row money to finance their crops. Bankers see pesti-cides as crop insurance, protection for the crops on which they're lending the money, he says. They're suspicious of anyone trying to get away with less.

But what if there were a form of crop insurance for doing the right thing?

That's what Jim Cubie, director of the Agriculture Conservation Innovation Center, is trying to pull off. With a three-year, $298,551 Joyce grant to ACIC's parent organization, the Natural Resources Council of America, Cubie aims to develop a fund to insure farmers who cut back on pesticides against any losses they might incur as a result.

A former staffer on the U.S. Senate Agriculture Committee, Cubie argues that financial incentives are what really shape farming practices. But conser-vation advocates and farm finance people seldom talk to each other, he says. "We need someone to look for solutions, not just take positions. We need to find new ways, primarily through the private sector, to deliver pro-farmer conservation messages."

Such messages especially need to address the ques-tion of financial risk. Farmers routinely use pesticides as a preventive measure, before pests even appear, or they use more than strictly necessary to control the problem. Cutting back, many fear, might put crops (and profits) at risk. Studies by the National Academy of Sciences, funded by Joyce, found that perception of risk is a key barrier to adoption of safer pest control and soil and water conservation practices.

Standard crop insurance, which covers losses when they exceed 35 percent of the crop, doesn't help with the smaller losses farmers fear if they change their

8 TheJoyceFoundation May 1998

9 WorkInProgress May 1998

design firm Kym Abrams Design, Inc.
creative director Kym Abrams
designer Kerry LaCoste

Joyce Foundation Work in Progress Newsletters ■ Through grants, The Joyce Foundation supports efforts to protect the environment of the Great Lakes, to reduce poverty and violence in the region, and to ensure that people have access to good schools, jobs, and culture. It uses its newsletter, *Work In Progress*, to share with the community the work of its grantees. Kim Abrams Design created a very simple grid for the newsletter that makes layout easy and enables stories to run to any length and end at any point on the page.

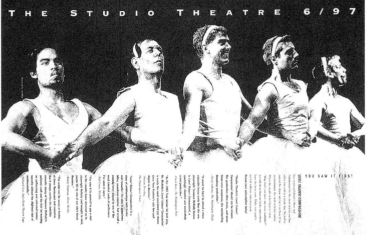

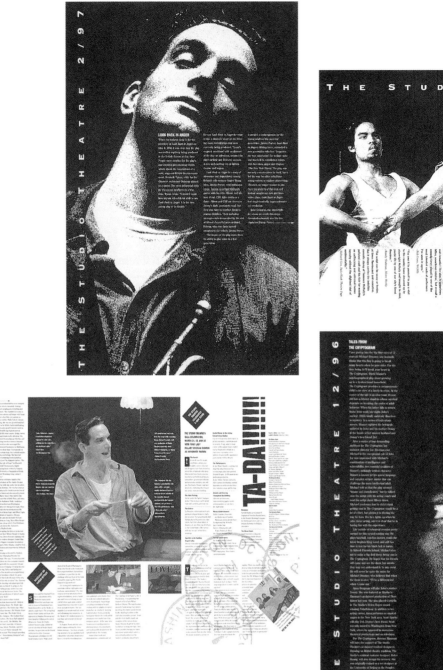

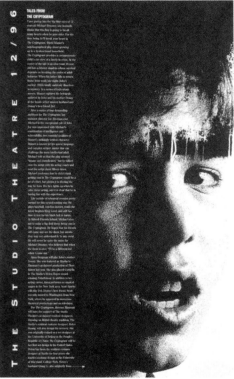

design firm MarketSights
designer Marilyn Worseldine

The Studio Theatre Newsletters ■ The Studio Theatre is small. Its budget is very tight. For more than twenty years, it has used black in all of its designs—for economic as well as dramatic reasons. Its newsletter is an extension of that tradition. Designer Marilyn Worseldine likes the short, vertical columns of her design because it makes so much variety possible.

"Well, one afternoon I saw this dog and he was walking down an alley. I think maybe it was August. Maybe it was July. Anyway, it was hot. I remember it was hot because I saw those kind of invisible heat waves coming off the pavement. And this dog stops, looks back at me. It was as if he was asking me for a drink of water. But then he turns and walks away. As he steps into the street, one of those big package delivery trucks comes to a screeching halt. The dog frantically jumps back onto the sidewalk. A grocery clerk is stacking red apples in front of the grocery store and as the dog jumps back, the dog collides with the grocery clerk and scatters red apples all onto the pavement. The dog runs away." *Momentum Designer*

MOMENTUM
TEXTILES
A MOVING SOURCE OF INSPIRATION

"Before my father sold insurance, he was a jazz musician. Saxophone. 1968. New York. He lived in a high-rise apartment building. A small group of fellow jazz players always played together at the end of the day up on the roof. Hot summer sunsets looking down on the rooftops. My father gave up his jazz career but not his jazz. Every evening growing up he gave me a saxophone serenade. Miles Davis, Wayne Shorter, Roger Ayers. All the Greats. But his favorite was Miles Davis. This was my fondest memory of my father. On a recent trip, feeling rather beat down, I rode trancelike the glass elevator to my high-rise hotel room. And then I heard it. Over the elevator sound system. Miles Davis. It was the end of the day and the rooftops below me glowed in the setting sun." *Momentum Designer*

MOMENTUM
TEXTILES
A MOVING SOURCE OF INSPIRATION

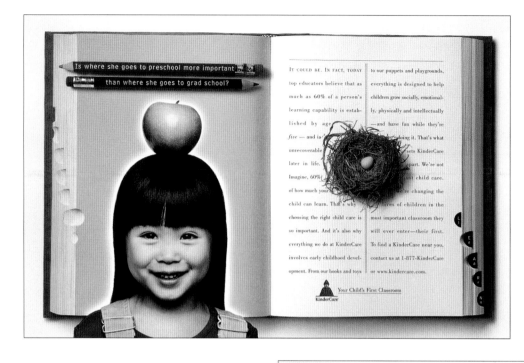

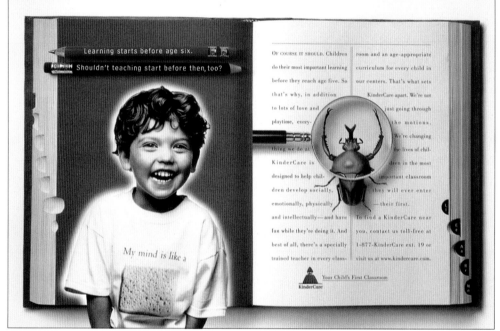

design firm Slaughter Hanson

designers Terry Slaughter, Marion English Powers, Jennifer Martin

copywriter Jack McDonald

Kindercare Ads ■ These heavily formatted but relaxed ads offer many charming points of entry. From the irresistible smiles and bits of flora and fauna to the thought-provoking copy, the ads cause the reader to pause and want to become involved with the information. The client wanted to change consumer perception to recognize that it was not only a child-care facility, but also a source for early childhood development. The message is loud and clear: Learning is fun here.

design firm Tango Design Ltd.
art director Peter Rae
designer Roberto D'Andria

Tango Identity ■ Tango's identity is a very basic grid—an elongated rectangle divided in half. The idea behind the very basic mark is to emphasize their partnership with the client, as in "it takes two to tango": Letterhead and address labels include the client's name as part of the design. Business cards display the cardholder's name in the lower block; various stickers accommodate various job designations in the same space.

design firm	EAI
creative directors	Matt Rollins, Rick Anwyl
designers	Todd Simmons, David Cannon
copywriter	Various
illustrator	Scott Menchin
photographers	George Lange, Norman Jean Roy, Carl Zapp
printing	Anderson Lithograph

IBM Annual Report ■ Since its fabled turnaround in the mid-1990s. IBM has regained its position as an industry leader. IBM employees and the company's technologies are the company's primary sources of innovation, growth, and profitability, says EAI creative director Matt Rollins. They are now "the new blue." To demonstrate this graphically, EAI photographed 100 IBM employees from around the world. Alternate covers show both female or male subjects; crisp black-and-white photography portrays a hipper, more energetic employee base.

design firm	Rigsby Design
art director	Lana Rigsby
designer	Thomas Hull
copywriters	JoAnne Stone, Denise Guptill
photographer	Chris Shinn

Earth Tech Corporation Inserts ■ The Earth Tech Corporation is an environmental consulting firm that provides a range of technically and legally complex services to businesses and the government. To make sense of all of the company's complicated offerings, designers at Rigsby Design used simple typography and colors, all hung on the same grid, on each of the specific brochures. Each service division has its own unique color palette.

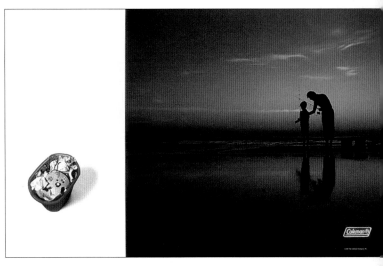

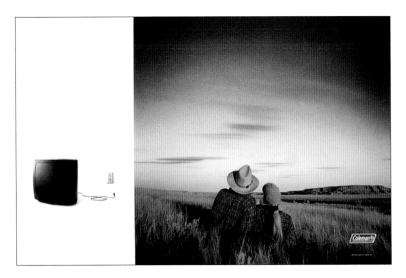

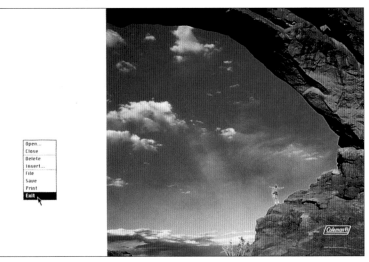

design firm Martin/Williams
creative director Lyle Wedemeyer
art director Jim Henderson
copywriter Tom Kelly
photographers Douglas Walker, Brian Bailey, Gary Kufner, Robin Hood
product photographer Curtis Johnson

Coleman Ads ■ Coleman knew that people don't get away as much as they used to, or as often as they would like. Martin/Williams knew that people associated the Coleman name with fond memories of camping trips. The advertising firm felt that it could invoke such memories and project them toward the future if it presented very dramatic photography with plenty of "visual quiet" in which the viewer could contemplate the scene.

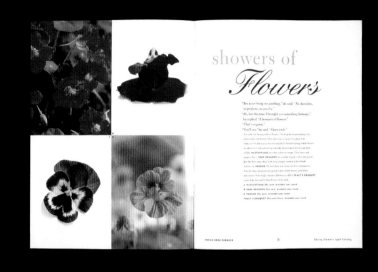

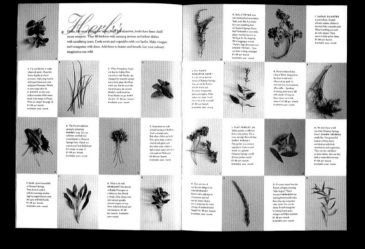

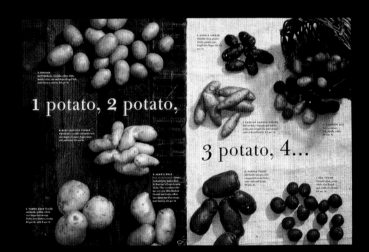

design firm Frank Baseman Design
art director Frank Baseman
designer Frank Baseman
copywriter Melissa Jacobs
photographer Bill Cramer

Indian Rock Produce Catalog ■ Indian Rock Produce has earned a name within the better-restaurant industry as a purveyor of very fine produce. Through the years, home chefs have pleaded with Indian Rock to make its produce available to them as well. Frank Baseman created this mail-order catalog to answer these requests. The idea behind his solidly gridded design was to work with the inherent beauty of the products themselves: "Farm chic," he calls it. Each photo was shot right at the Indian Rock warehouse in order to have the best access to the freshest selection of products.

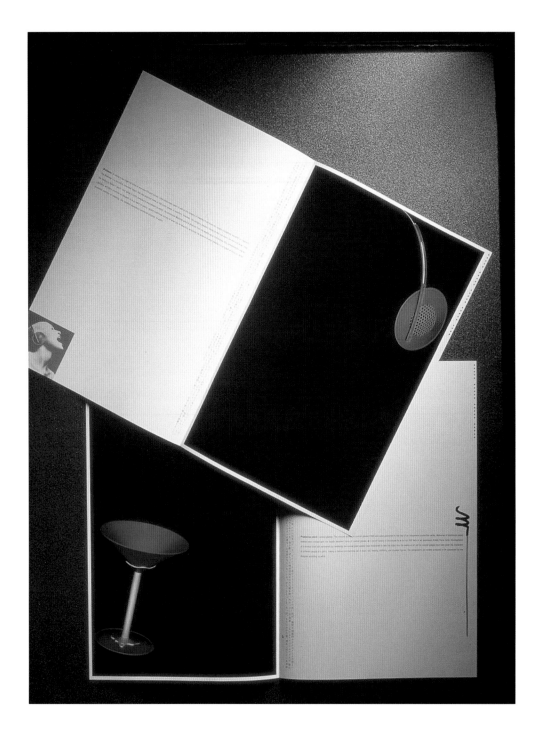

design firm Emery Vincent Design

designer Garry Emery

Susan Cohn Catalog ■ Jewelry artist Susan Cohn's work is modernist in spirit—clear, dynamic, and disruptive. The design of a catalog of her works had to have the same feel. Emery Vincent created a long, elegant format for her book, each spread containing a single item. The text and photos are delicately balanced to create a spare, contemplative layout that always keeps the product in focus.

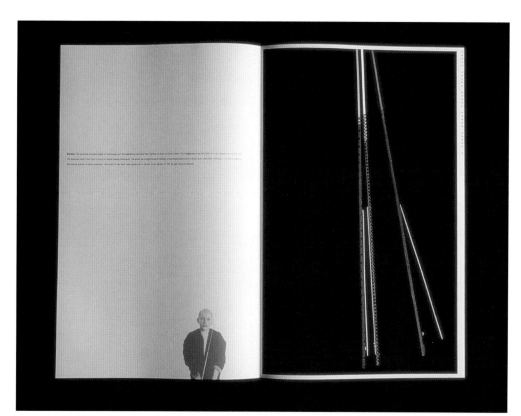

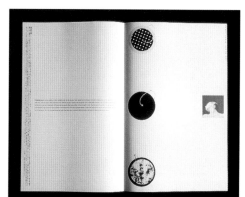

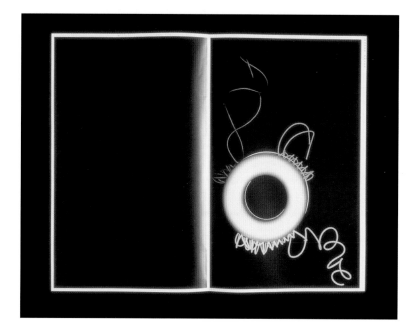

4.

What does a bulls-eye mean? A skull and cross-bones? A smiley face? ■ All of these images have become so ubiquitous that they function as international symbols. The images convey meaning directly. They don't need words, piled on in order for the reader to understand what they say. ■ That's the common thread of all designs in this section. Each piece contains a very pointed image that drills directly into the viewer's sensibilities. There are no visual off-ramps. ■ Most samples you will find here are absolute in their form. Stripped of incidental visual references, the images are almost impervious to corruption by subjectivity. They are what they are.

minimal
image

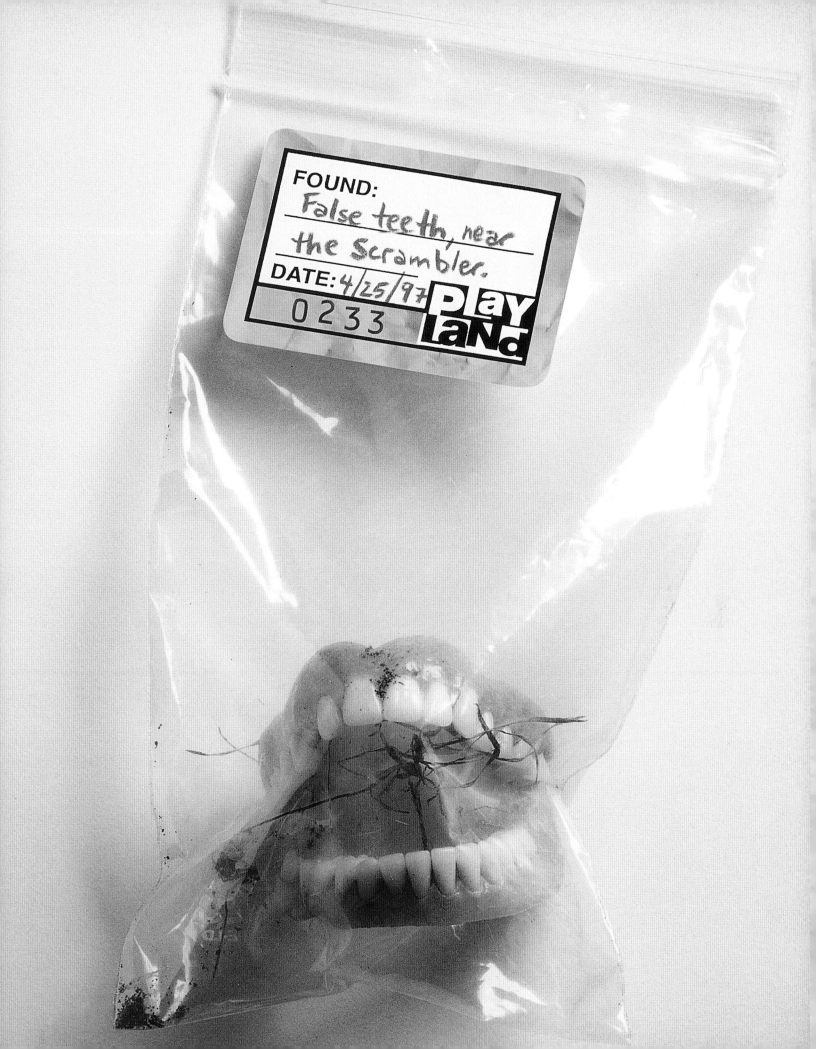

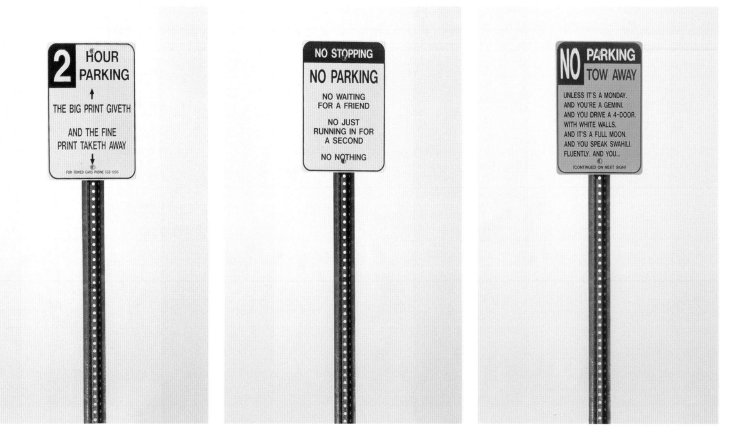

design firm West and Vaughan

art director Shawn Brown

copywriter Eran Thomson

photographer Vic Cotto

Corcoran Parking Advertisements ■ Eran Thomson, the West and Vaughan copywriter who created these darkly humorous ads for a parking lot service, notes that every real No Parking sign carries the same message as this series: They just use a different language. Posted on telephone poles and competing with real city signs, the ads appeared in cluttered, rushed, urban environments and had to capture attention in a glance.

No matter what personality your cabinetry exhibits, Häfele has more of your traits. Call 1-800-423-3531.

HÄFELE

design firm	Elberson Senger Shuler
creative director	Russel Shuler
art director	John Roberts
copywriter	Steve Lasch
account executive	Charlie Elberson

Häfele America Company Advertisements ■ Häfele America wanted interior design and home décor consumers to know that their company did more than make nuts and bolts: In fact, it offers thousands of styles of decorative hardware, enough to satisfy a world of design tastes and styles. To create a series of image-building ads (using existing catalog photography), art director John Roberts worked from the "personality" aspect of the products and invented a crowd of appealing postmodern characters. After running only two of the ads, the client received over one thousand inquiries, a full 12 percent of its customer base.

Alcoa Foundation

1996 Annual Report

design firm	Landesberg Design Associates
designer	Rick Landesberg
copywriter	Alan Van Dine
illustrator	Michael Ricci
typesetter	Full Circle Type

Alcoa Foundation Annual Report ■ Landesberg Design Associates faced a challenge in its sixth year of creating the Alcoa Foundation's annual report: Its designers were charged with conveying a broader sense of the foundation's mission with a budget that was less than half of the previous year's allowance. The firm's minimal solution was threefold: First, spare, witty illustrations by Michael Ricci deliver a smile with the content. Classical typography and an uncoated, textured paper are the second and third ingredients of the greatly refined design.

design firm Modern Dog
art director Vittorio Costarella
designer Vittorio Costarella
illustrator Vittorio Costarella

Long Wharf Theatre Promotion ■ The inspiration for this poster was also the only stage prop used in the one-person play: an IV connected to a woman. Created by Modern Dog to promote a performance about terminal cancer, the IV juxtaposes illness with the joy of life. The elemental look of the poster evolved directly from a tiny first sketch (plus a lack of time and budget). The result was a success: The play's audiences loved it, and the design landed in the Library of Congress' permanent collection.

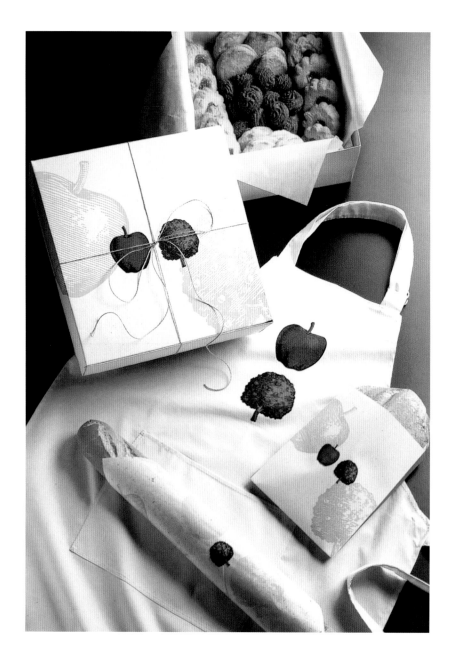

design firm	Pentagram Design
designer	Lowell Williams
copywriter	Andy Dearwater

Apple Tree Markets Identity ■ After a group of employees bought out a portion of a well-known national supermarket chain, the new store needed a very separate, very distinct identity. The new management approached Pentagram Design, whose designers created a pictogram for Apple Tree Markets that even its youngest, nonreading customers, can read. The simple drawing style hearkens back to antique fruit-crate labels. Its freshness differs markedly from the plastic look typical of supermarket graphics.

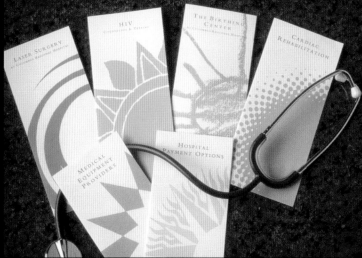

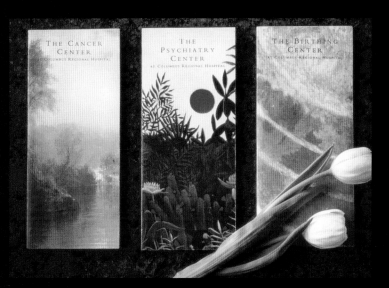

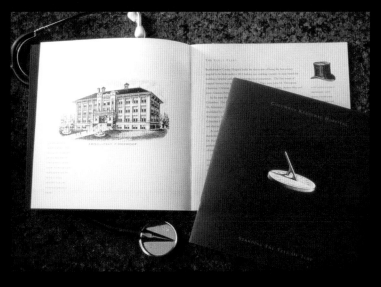

design firm Pentagram Design

partners Michael Gericke, Michael Bierut

art directors Michael Gericke, Michael Bierut

designers Michael Gericke, Jim Anderson, Jane Ascheim, Donna Ching, Sharon Harel

coordinator Moira Cullen

Columbus Regional Hospital ID Work ■ Pentagram Design's identity work for the Columbus (Indiana) Regional Hospital centers around the concept of a sun. Although a standardized, graphic logo is used on stationery and other in-office collateral, the palette of suns is greatly expanded on other designs. From painterly to graphic, the symbol exudes a sense of health, life, and vitality. The result is a warm, professional image.

design firm Office of Ted Fabella

designer Ted Fabella

AIGA Atlanta Big Night Poster ■ AIGA Atlanta's most important annual event had previously been called "Sponsor-Patron Night," a title that Ted Fabella reports repelled designers in droves. He suggested to the group that because it was the biggest night of the year for the organization, why not call it something sexier, like "The Big Night"? Wanting to create a visual and verbal pun for the poster/mailer that would imprint the newly approved name in people's minds, he created a giant moon that dwarfed the city of Atlanta. Cropping the sides off of the moon and using very small type for the title emphasized the size of the orb even more. Fabella reports that attendance rose dramatically.

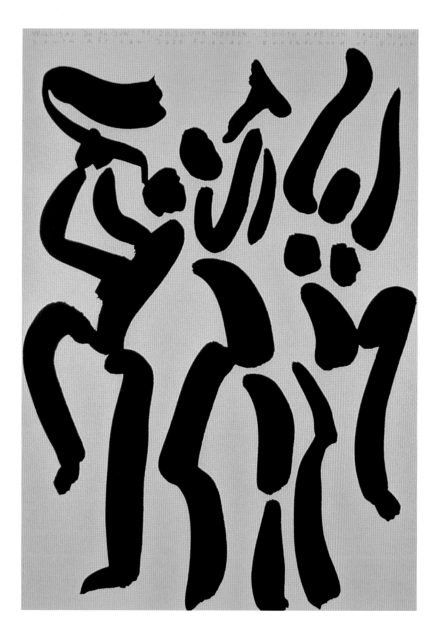

design firm Niklaus Troxler Grafik Studio

South African Jazz Friends Poster ■ Designer Niklaus Troxler did not work from photos to create the art for this bold poster design, although the movement and vitality of line in this South African Jazz Night announcement might indicate otherwise. Instead, he studied African art and then created many, many brush and ink drawings, working spontaneously until he hit upon the right combination of representation and symbolism. The artist explains that the shapes had to be spontaneous and free, like South African music and dance.

designer Niklaus Troxler

Personal Project ■ Designer Niklaus Troxler created this forceful poster as a personal statement to demand that Switzerland enter the European Union. Troxler transformed the Swiss flag—with its familiar white cross on a red field—into the colors of the European Union, yellow and blue. Although many Swiss viewers were shocked to see their flag in such strange colors, the work was memorable: In addition to being selected as the Swiss Poster of the Year, it was a top prize winner at competitions in Finland, the Slovak Republic, and Germany.

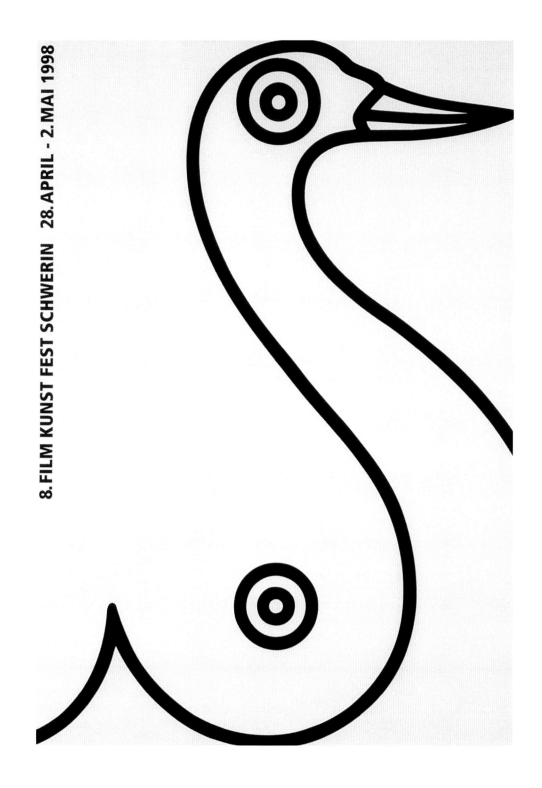

8. FILM KUNST FEST SCHWERIN 28. APRIL - 2. MAI 1998

designer Niklaus Troxler

Film Kunst Fest Schwerin Promotion ■ The theme of the 1998 Film Art Festival at Schwerin, Germany, was erotic films. In a poster to promote the event, designer Niklaus Troxler tied the theme of the festival to its content, referencing the classic erotic tale of Leda and the swan. Sinuous, hand-drawn lines form shapes that are clean enough to act as a logo, and white space is as important as the lines themselves.

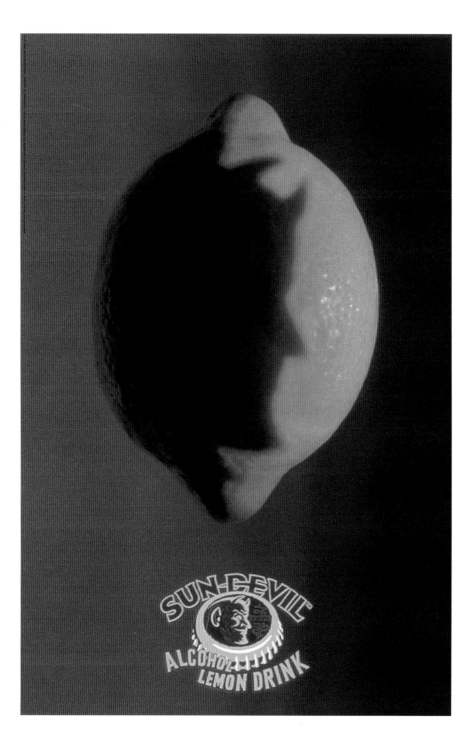

design firm Turner Duckworth
art directors David Turner, Bruce Duckworth
designer David Turner
photographer Stan Musilek

The Steel Brewing Company Advertisements ■ Sun Devil brand lemonade contains alcohol and is definitely a drink for adults. Design firm Turner Duckworth wanted its point-of-purchase poster to convey two strong messages: "made with real lemons" and "with a darker side." Aside from announcements on the client's Web site, the in-store poster was the new product's sole advertising vehicle, so its impact was crucial to establish brand identity. The designers decided that a visual, emotional, "no-copy" approach would work best and would add intrigue and mystery to the product.

design firm Ted Bertz Graphic Design
art director Dawn Droskowski
designer Dawn Droskowski
illustrator Dawn Droskowski
printing Hull Printing Co.

Middlesex County Chamber of Commerce Regatta Poster ■ Ted Bertz Graphic Design has created posters for the Head of the Connecticut Regatta for 15 years; designer Dawn Droskowski designed the last eight herself. Past works have included Polaroid transfers, paintings, and other more illustrative images. For the poster here, Droskowski wanted something completely graphic. The original computer-built image was distilled by gradually removing visual information— until it became as spare as possible and still be "read."

design firm Perich & Partners
creative director Ernie Perich
designers Carol Mooradian, Carol Poholsky
illustrators Skidmore, Colorforms

Briarwood Mall Billboards ■ Perich & Partners' client presented the advertising and design firm with a list of stores it wanted to feature in its billboards for the year. Some unlikely combinations were in the group, but Perich Partners found a way to pair certain partners: by shape. After listing images that would represent each store in a very fundamental way, they could match the top of Daffy Duck's head with a wingtip shoe; a William-Sonoma ladle with a the big dipper; and so on. The recipe has proven successful: The billboard series now has thirty installments to its credit.

design firm Jon Flaming Design
art director Jon Flaming
designer Jon Flaming
illustrator Jon Flaming

Creative Printing Postcards/Posters ■ Creative Printing is a midsized print shop. Designer Jon Flaming wanted to convey the shop's fun, loose, and approachable style in a set of postcards and posters he was assigned to create. He began with the tagline, "You're creative, we're creative." Then he sought an image that loudly proclaimed creativity: The dancing figure had just the right attitude. Inside the figure, Flaming used imagery and patterns that were relevant to specific events or to creativity in general.

E L I S A B E T H

A N D E R S E N

{DRESSES}

design firm Jon Flaming Design
art director Jon Flaming
designer Jon Flaming
illustrator Jon Flaming

Elisabeth Andersen Dresses Promotion ■ Elisabeth Andersen has a very high-end clientele, a select group of women looking for expensive, one-of-a-kind party dresses that are elegant and simple. To design a poster/giveaway for his client, Jon Flaming wanted to create an Audrey Hepburn-like image, one that was as clean and elegant as possible. His design was so minimal that it only suggests the woman's body; the dress and hat capture all of the attention. The reaction to the promotion was overwhelmingly positive: The dressmaker saw sales increase immediately after the design's debut.

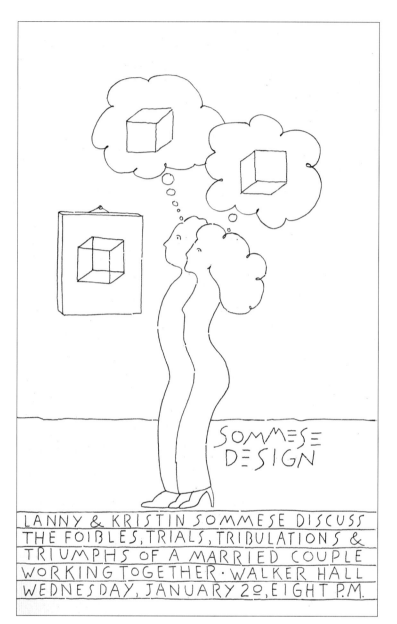

design firm Sommese Design
art directors Kristin Sommese, Lanny Sommese
designers Kristin Sommese, Lanny Sommese
illustrator Lanny Sommese
printing The Copy Co., Seattle

AIGA Philadelphia Lanny & Kristin Sommese Self-Promotion ■ Well-known for deceptively simple line drawings that are rich with meaning and visual tricks, Lanny Sommese says that images relating to himself and wife/partner Kristin Sommese seem to flow naturally from their teamwork. Their professional, married, and family lives are full of interpersonal events that offer terrific fodder for conceptual images. They resonate with their audiences because those people are going through the same kinds of things in their lives. Sommese uses simple lines because their neutral style presents the Sommeses' ideas without competing with them. He frequently breaks the lines to keep the overall image richer. For even more interest, he composes his original Pentel pen drawings on a small scale, then enlarges them to poster size in order to amplify the idiosyncratic nature of his lines.

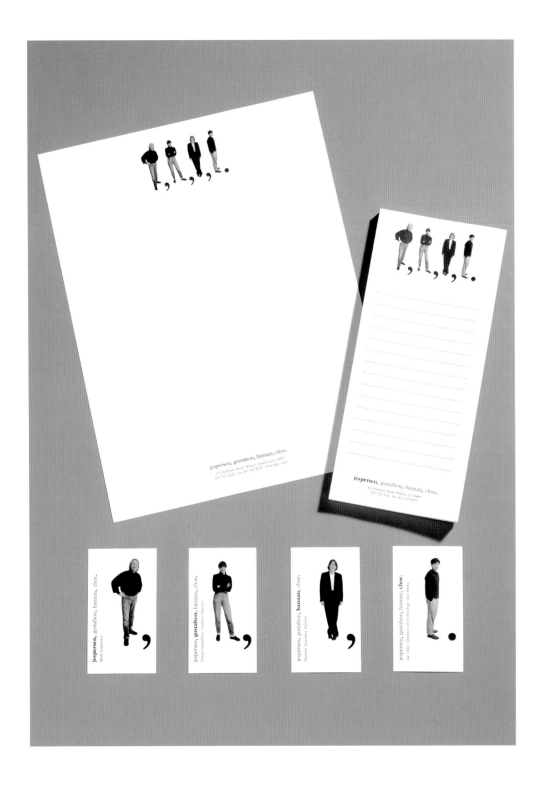

design firm Joe Advertising
creative director Sharon Occhipinti
art director Sharon Occhipinti

Jespersen. Gustafson. Hannan. Choe Stationery ■ Four equal partners run the design firm Jespersen, Gustafson, Hannan, Choe. Their company is all about people—their relationships with clients and each other. Sharon Occhipinti felt the best way to represent this graphically was to have the partners show up in person. On business cards, a single person appears. On all other materials, the team makes a group appearance.

1998
in a new light

MIRIELLO GRAFICO

I've stood here before— what changes is the moment that brought me here,
the direction I face

1 2 3 4 5 6 | 7 8 9 10 11 12 13 | 14 15 16 17 18 19 20 | 21 22 23 24 25 26 27 | 28 29 30

JANUARY '98

Close your eyes and see

1 2 3 4 | 5 6 7 8 9 10 11 | 12 13 14 15 16 17 18 | 19 20 21 22 23 24 25 | 26 27 28 29 30 31

design firm Miriello Grafico
designers Nick Adadilla, Michelle Aranda, Liz Bernal, Terry Christensen, Courtney Mayer, Ron Miriello, Mike Ozaki, Maureen Jan Wood
photographer Paul Body
printing Neyenesch Printing

Miriello Grafico Calendar ■ After working hard all year, designers at Miriello Grafico consider the creation of their annual year-end gift to clients a chance to play. The criteria for the content of the 1998 calendar were simple: Each page must carry a face, and the company initials must be hidden somewhere inside the image. "Insider" information was tucked in as well, details that only their clients and friends would recognize. Designers scavenged flat files and desk drawers for 1997 memorabilia. Then they pulled together personalities that could only have emerged from Miriello Grafico's offices.

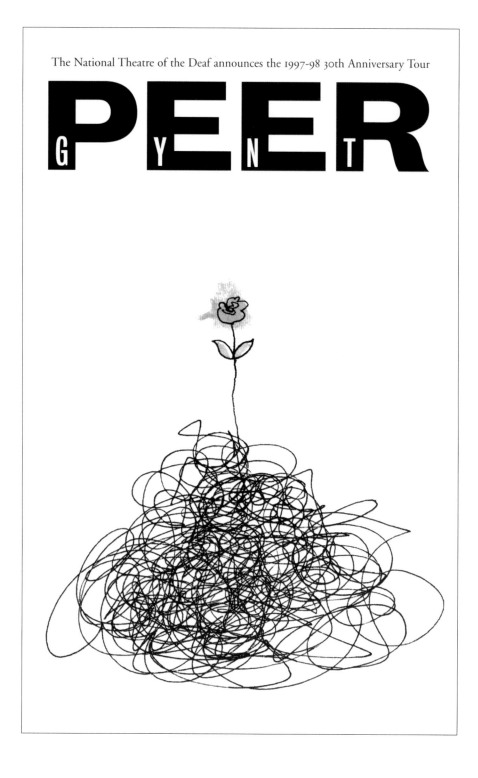

The National Theatre of the Deaf announces the 1997-98 30th Anniversary Tour

PEER GYNT

design firm Cummings & Good
designers Peter Good, Chris Hyde

National Theatre of the Deaf *Peer Gynt* Postcard ■ *Peer Gynt* is a play that revolves around the misguided adventures of a young man who leaves his home and the love of his life to find his true self. Through the many lives he has throughout the play, he finds the life that held his true self was the one he left behind many years ago. He returns home to find his faithful lover waiting for him. On a postcard to advertise the performance to booking agents, designer Chris Hyde scribbled a line illustration symbolizing that a life lacking direction can end happily—an illustration with the same emotional clarity as the play.

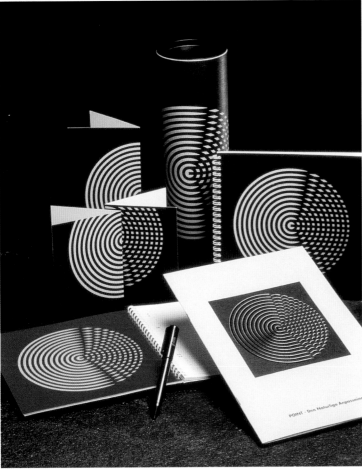

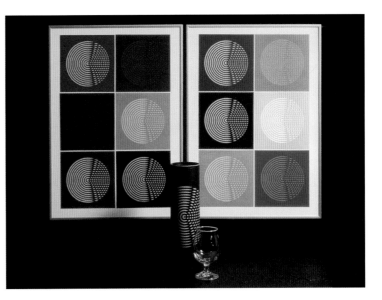

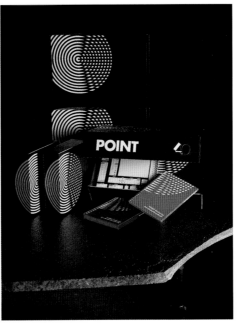

design firm Studio Bubblan

art director Kari Palmqvist, Jeanette Palmqvist

Cadpoint POINT Spiral Designs ■ POINT is a group of CAD programs developed by Cadpoint. The product line includes products for building design, building services design, and civil and infrastructure design, all very advanced tools that develop and grow as the trends and technology change. Jeanette Palmqvist of Studio Bubblan wanted to create a "living" logo for the product, one that would convey its sense of motion. Her finished design moves every time it is viewed, a complicated visual illusion that is a good match for the stark POINT wordmark (see vehicle photo).

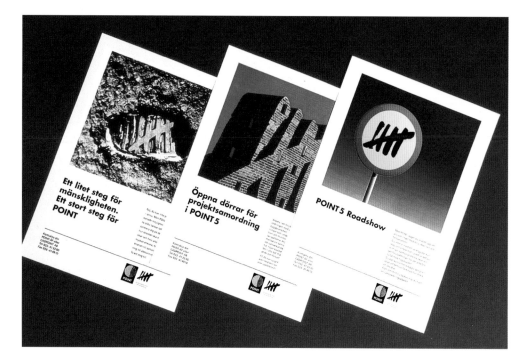

design firm Studio Bubblan

designers Kari Palmqvist, Jeanette Palmqvist

Cadpoint POINT 5 Graphics ■ For the latest release of POINT CAD tools, the fifth in a series of building, civil, and infrastructure design tools, manufacturer Cadpoint wanted to make a strong statement. Jeanette Palmqvist of Studio Bubblan decided that a common five-count hash mark device would celebrate the landmark event in any language. Its roughness creates an effective contrast with the POINT logo and wordmark, both of which are very precisely rendered. The mark was used on the product itself, on holiday cards, and on a variety of ads.

design firm Palmer Jarvis DDB

creative directors Chris Staples, Ian Grais

art director Ian Grais

copywriter Alan Russell

Playland Ads ■ Playland is an amusement park with a highly acclaimed wooden roller coaster. Palmer Jarvis was asked to create a series of ads that communicated the thrills and excitement of the roller coaster and other rides to parents and kids. The black humor in the resulting transit shelter, interior transit, and billboard postings says plenty, without the use of a single word.

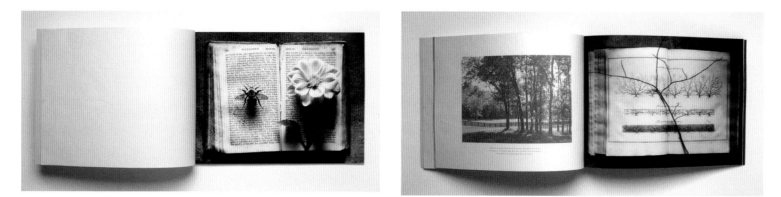

design firm Slaughter Hanson

designers Terry Slaughter, Marion English Powers, Jennifer Martin

Ben Page Associates Book ■ Lush, mysterious, elemental, rich—all of these describe the Ben Page Associates landscape brochure, designed by Slaughter Hanson. The concept for the book came from the client's elegant, old-world, hands-on approach to gardening. Behind every Ben Page project is a story. So the designers allowed pictures to tell the stories. Targeted high-end residential clients have responded extremely well to the brochure.

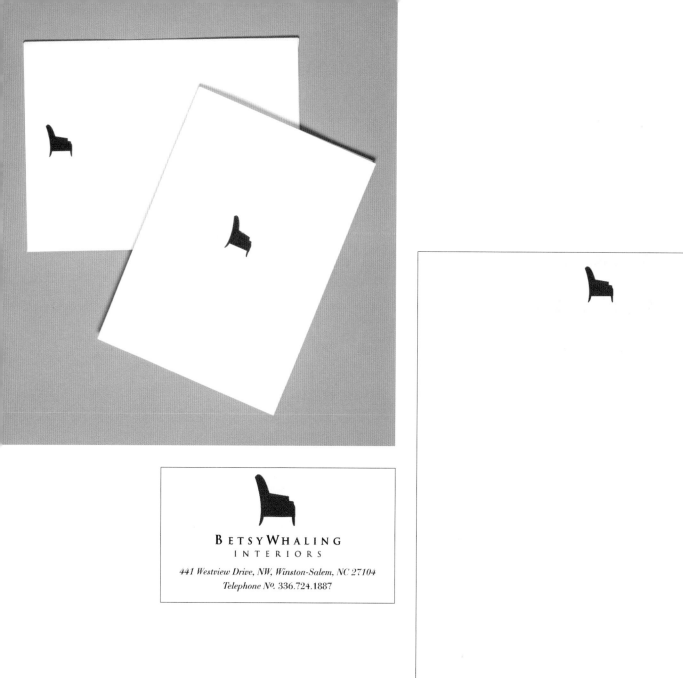

BETSY WHALING
INTERIORS

441 Westview Drive, NW, Winston-Salem, NC 27104
Telephone № 336.724.1887

BETSY WHALING
INTERIORS
441 Westview Drive, NW, Winston-Salem, NC 27104 • Telephone № 336.724.1887

design firm Henderson Tyner Art Company
creative director Hayes Henderson
designer Will Hackley

Betsy Whaling Interiors ■ Henderson Tyner Art Company's client, an interior and residential design firm, did not want to appear too trendy or too conservative. A simple, classic chair silhouette rendered in a vibrant red seemed to strike the right balance. The stationery system is printed on a linen-textured paper, a very subtle visual cue to the client's trade.

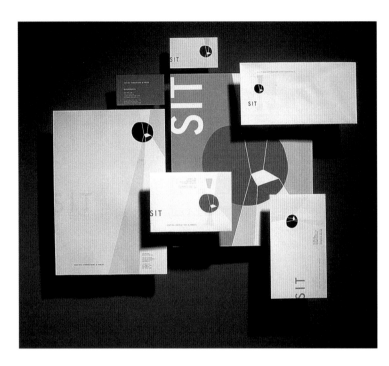

design firm Cornwell Design Party
designer Jane Sinclair

SIT Brochure ■ With the café culture of the 1990s exploding in Melbourne, hospitality seating is in high demand in Australia. SIT—short for "seating innovations and tables"—created a concept showroom to provide a complete range of products for restaurateurs, interior designers, and the domestic market. Cornwell Design developed an exciting identity, a complete range of stationery, signage, and marketing materials that reflect the energy of the hospitality industry.

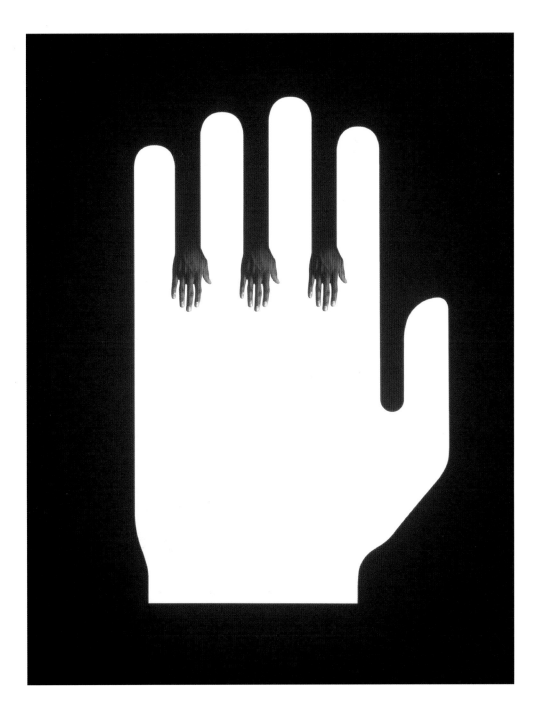

design firm Mirko Ilić Corp.

art director Steven Heller

designer Mirko Ilić

The New York Times Book Review Hand Illustration ■ Mirko Ilić created this stark illustration for the *New York Times Book Review* to accompany an article titled "Arguing Affirmative Action" that presented reviews of two books, one for the movement and one against. His concept played on the simple unity shown by the positive and negative spaces of the hands reaching toward each other.

A graphic design with a minimal message speaks clearly, often with no copy. Even the most cursory glance reveals an instant visual communique. ■ Most work in this section plays off of people's common perceptions. But the designs twist those perceptions in new shapes that make us pause and rethink. Sometimes the message prompts humor; sometimes it rattles the nerves. Either way, the viewer remembers it. ■ It's a risky proposition: With no words for props, an entire design can fall flat if the reader doesn't get the message. It's up to the designer to present the message at a level that is neither too oblique nor even worse, trite. The message must speak plainly.

minimal
message

THE AMERICAN ACADEMY OF ARTS AND SCIENCES

THE GETTY CENTER FOR THE HISTORY OF ART AND THE

THE UNIVERSITY OF CALIFORNIA HUMANITIES RESEARCH

CENSORSHIP +

SILENCING

PRACTICES OF CULTURAL REGULATION

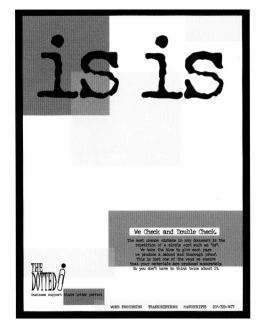

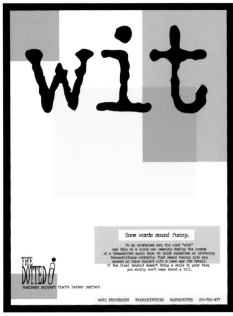

design firm Sunspots Creative, Inc.

art director Richard Bonelli

designer Deena Hartley

Dotted i Direct Mail Pieces ■ After reviewing promotional materials for word-processing and business-support services that competed with its client, Sunspots Creative found those materials to be bland, one-color designs littered with generic clip art. Sunspot designers knew that if they created something bold and colorful, their client's materials would stand out dramatically. Big blocks of color combined with oversized headlines had just the right level of excitement. The Dotted i has reported a nearly 60 percent callback rate from its mailing list.

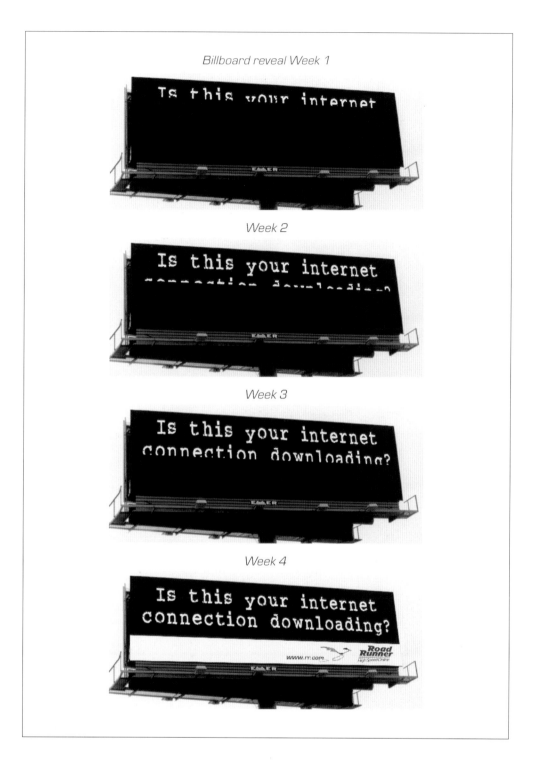

Billboard reveal Week 1

Week 2

Week 3

Week 4

design firm Mad Dogs & Englishmen

creative director Dave Cook

art director Darren Lin

copywriter Deacon Webster

Roadrunner High Speed Online Billboards ■ "The utter sloth of the internet" is what designers at Mad Dogs & Englishmen say inspired this billboard, which was changed on a weekly basis until the full message finally was revealed. Positioned in high-traffic areas that guaranteed a regular audience, the board skyrocketed awareness of the client.

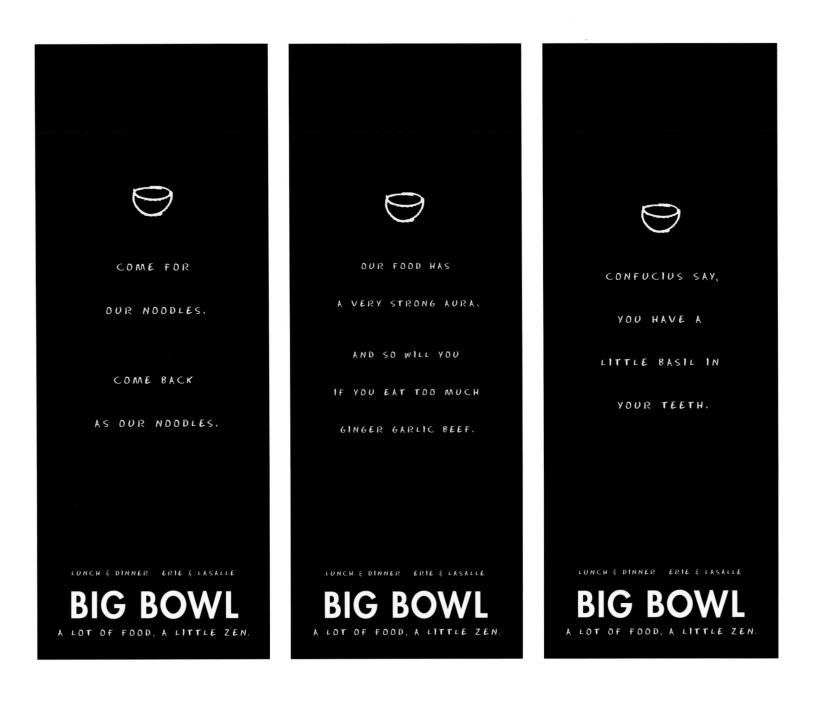

COME FOR

OUR NOODLES.

COME BACK

AS OUR NOODLES.

LUNCH & DINNER ERIE & LASALLE
BIG BOWL
A LOT OF FOOD, A LITTLE ZEN.

OUR FOOD HAS

A VERY STRONG AURA.

AND SO WILL YOU

IF YOU EAT TOO MUCH

GINGER GARLIC BEEF.

LUNCH & DINNER ERIE & LASALLE
BIG BOWL
A LOT OF FOOD, A LITTLE ZEN.

CONFUCIUS SAY,

YOU HAVE A

LITTLE BASIL IN

YOUR TEETH.

LUNCH & DINNER ERIE & LASALLE
BIG BOWL
A LOT OF FOOD, A LITTLE ZEN.

design firm	Arian, Lowe & Travis
art director	Jennifer Pitt
copywriter	Shannon Lavin

Big Bowl Ads ■ This series of Big Bowl ads was created to run in an alternative Chicago newspaper to promote a nontraditional Asian restaurant. The store has authentic food, but it also has a fun, updated atmosphere. So art director Jennifer Pitt mixed a traditional Zen-like flavor with contemporary humor in these extremely simple designs. The mostly black ads also had the advantage of visually popping off of the newspaper's gray pages.

The last time you had a cozy dinner for two, was one of you eating Tender Vittles?

To place your free personal ad, or for information on our latest listings, call 1-800-474-9046.
Person to Person. In your local paper.

If you like Piña Coladas, getting caught in the rain. If you're not into perverts, or guys who wear chains.

To place your free personal ad, or to learn about our exclusive screening system, call 1-800-474-9046.
Person to Person. In your local paper.

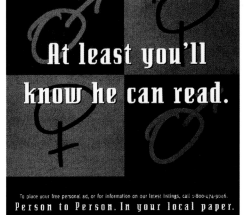

At least you'll know he can read.

To place your free personal ad, or for information on our latest listings, call 1-800-474-9046.
Person to Person. In your local paper.

Man cannot live by Baywatch alone.

To place your free personal ad, or for information on our latest listings, call 1-800-474-9046.
Person to Person. In your local paper.

design firm Arian, Lowe & Travis
art director Jennifer Pitt
copywriter Shannon Lavin

Brite Voice System Person To Person Ads ■ Copywriter Shannon Lavin says the voice for these personals ads came out of single hood's inherent humor: Some experiences are ruefully common. She and art director Jennifer Pitt also wanted to remove the stigma of using a personal ad by putting people at ease with a bit of understanding. The message is that maybe using a personals ad isn't so radical after all.

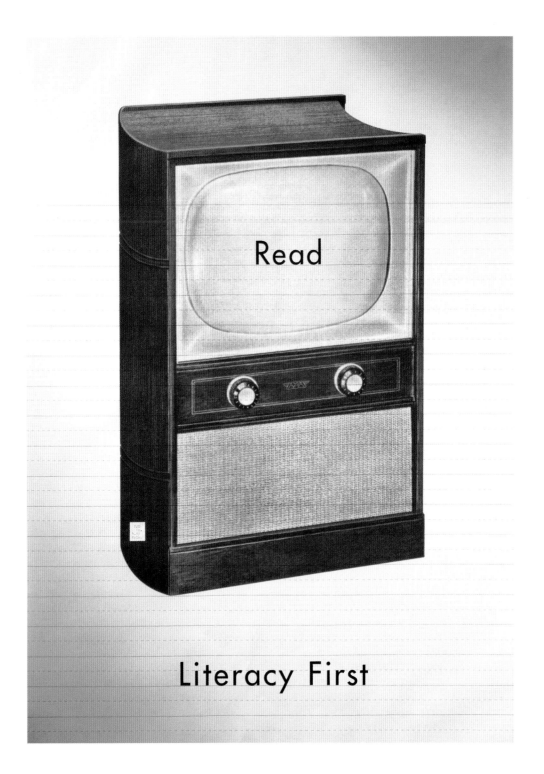

Read

Literacy First

design firm Haley Johnson Design Co.
designer Haley Johnson
photographer Richard Boynton
illustrator Richard Boynton

AIGA Colorado Literacy First Promotion ■ Haley Johnson Design brought together three very familiar, basic icons for this poster created for a special AIGA literacy event in Denver: a television morphing into a book, all laid on a backdrop of lined school paper, meant to symbolize learning. Specifying a primer-style typeface and using period illustrations all contribute to the back-to-basics message. Designers say they had early confirmation that the concept was effective: A press operator running the job said he was going to frame one for his child, who he felt watched far too much TV.

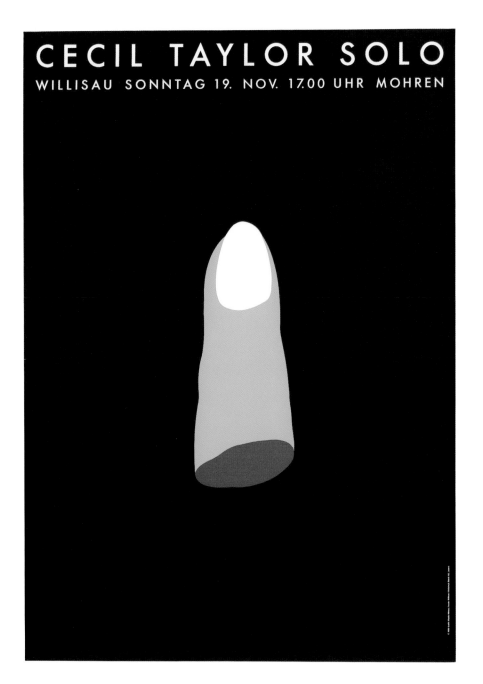

design firm Niklaus Troxler Grafik Studio

Cecil Taylor Poster ■ Designer Niklaus Troxler used an "abbreviated" finger as a symbol for what he calls the "kamikaze-like" performance of pianist Cecil Taylor. The single finger also works on other levels: It neatly represents the idea of "solo"; its surreal appearance represents the musician's surrealistic performances; and the very odd color combination on the amputated digit undeniably grabs attention. Troxler felt that the strange green color created an interesting contrast with the blood-red color and symbolized the strong vitality in the pianist's work.

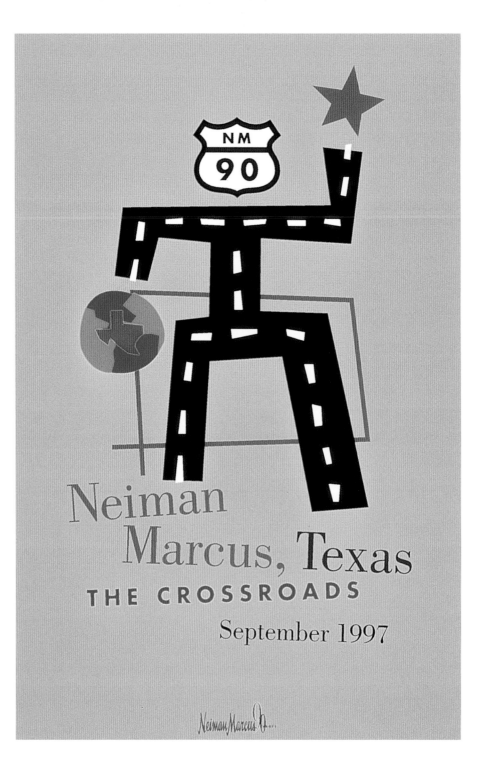

design firm Jon Flaming Design
creative director Georgia Christensen
art directors Clay Freeman, Jon Flaming
designer Jon Flaming
illustrator Jon Flaming

Neiman Marcus Road Man ■ Jon Flaming's inspiration for the Neiman Marcus "road man" sprang from 1930s poster art. He liked the simplicity of that era's design and illustration, and he felt that it conveyed the right sense of style and sophistication for his client. It felt very loose and whimsical, and it suggested the client's location. Flaming used the digitally created image on a large-format poster, a giveaway distributed at the client's ninetieth anniversary event.

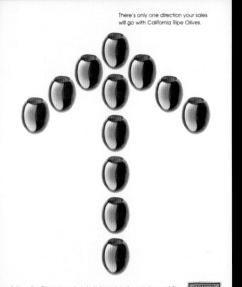

There's only one direction your sales will go with California Ripe Olives.

California Ripe Olives enhance the taste, texture and visual appeal of any meal. Their flavor, consistency and dramatic good looks have made them a symbol of quality across America. Which means their added value can help you command higher menu prices and increase profits. If you'd like to learn how you can put together a successful California Olive promotion, give us a call at 1-800-452-4993 or contact us at www.calolive.org. We'll get you headed in the right direction.

CALIFORNIA RIPE OLIVES

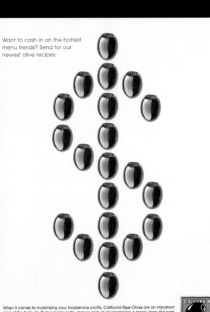

Want to cash in on the hottest menu trends? Send for our newest olive recipes.

When it comes to maximizing your foodservice profits, California Ripe Olives are an important part of the formula. Their superior taste, texture and visual appeal have made them the best-selling table olives in America. It's no wonder they can enhance the value of virtually any menu item. If you'd like to see how California Ripe Olives can increase your sales, order our free brochure, today. Just give us a call at 1-800-452-4993 or contact us at www.calolive.org. Then watch your mailbox. And your cash register.

CALIFORNIA RIPE OLIVES

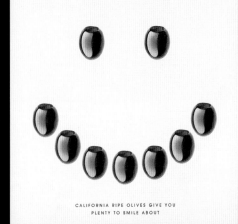

CALIFORNIA RIPE OLIVES GIVE YOU PLENTY TO SMILE ABOUT

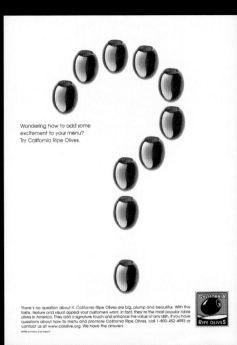

Wondering how to add some excitement to your menu? Try California Ripe Olives.

There's no question about it. California Ripe Olives are big, plump and beautiful. With the taste, texture and visual appeal your customers want. In fact, they're the most popular table olives in America. They add a signature touch and enhance the value of any dish. If you have questions about how to menu and promote California Ripe Olives, call 1-800-452-4993 or contact us at www.calolive.org. We have the answers.

CALIFORNIA RIPE OLIVES

design firm Zuckerman Fernandes + Partners
art directors Sebastian Dragnea, Katie Reuter
copywriters Alex Ochy, Kim Wilsey
photographer Allan Rosenberg

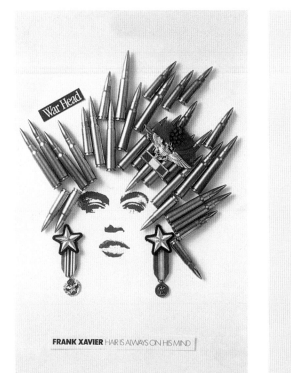

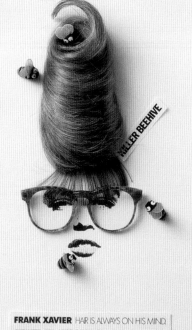

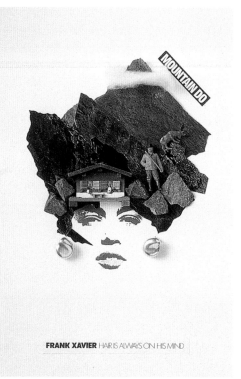

design firm Siegel & Gale
copywriter Jerry Cronin
photographer Myron

Frank Xavier Hair Ads ■ Frank Xavier came to Siegel & Gale with a very defined request: He wanted to be seen as the most creative hair dresser in Boston. The designers encouraged him to show, not just tell, the world. So instead of showing a pretty woman with a pretty haircut, he allowed the design firm to create ads that are spare yet stylish, fashionable yet fun.

design firm Siegel & Gale
creative director Cheryl Heller
designer Karina Hadida
photographers Various

ICP Book ■ In July 1994, over one million Rwandan refugees, displaced by civil conflict, descended upon the small town of Goma, Zaire. Among them were thousands of lost or orphaned children. Photographers Seamus Conlan and Tara Farrell worked with UNICEF and the Red Cross to photograph more than 20,000 children, each with an identification number. The children's photos were displayed in refugee camps; those who were recognized were reunited with their families. Seventy of the children and their beautiful, poignant faces are shared on the cover of the International Center of Photography report. With something this powerful, says creative director Cheryl Heller of Siegel & Gale, adding anything else would have lessened the cover's design, not added to it.

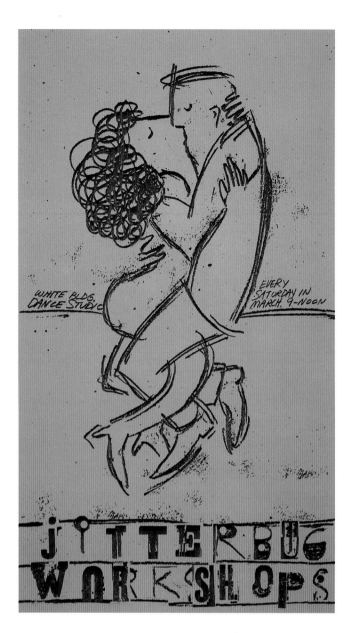

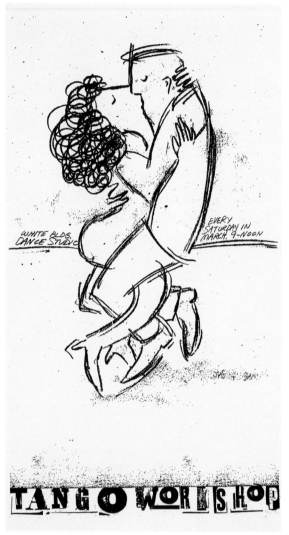

design firm	Sommese Design
art director	Lanny Sommese
designer	Lanny Sommese
illustrator	Lanny Sommese

White Building Dance Studio Workshop Flyers ■ Although both of these flyers use the same image, their messages are subtly different. Lanny Sommese created a small version of the art in pencil, then dramatically enlarged the image and added sketchy marks to enhance its motion. Both designs evince energy and emotion. But Sommese made each communicate something different. By using different flavors of type, varying sizes of copies, and colors that seemed to match the nature of the specific dance (blue for the moody, romantic tango and hot pink for the exuberant jitterbug), two separate messages were delivered with the same image and design.

Christmas

wish everything could be this simple

card

(scratch n' sniff)

Mmmm, there's nothing like the smell of fresh Christmas cards.

design firm Joe Advertising
designer Sharon Occhipinti

Joe Christmas Cards and Matches ■ In addition to being downright inexpensive and humorous, Sharon Occhipinti's Christmas cards are an apt personality match for her freelance business, Joe Advertising. Their spare wit reminds clients about how much the designer can do with the simplest of materials. Another promo, imprinted matchbooks, have the same, almost anonymous quality. In the context of Occhipinti's creative abilities, however, they say a lot about her intelligent sense of fun.

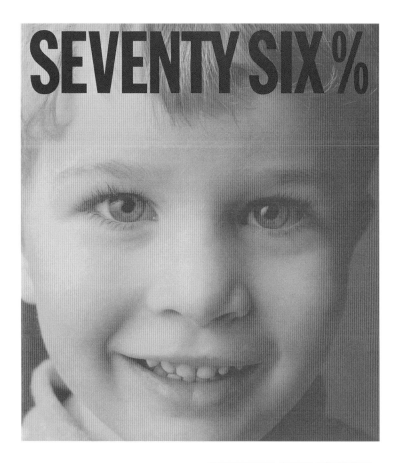

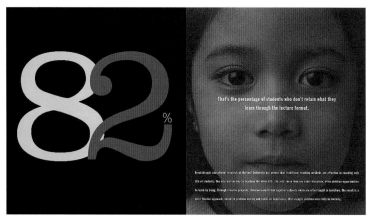

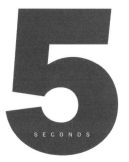

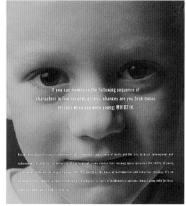

design firm HM&E, Inc.
designer Paul Haslip
copywriter Shaun Elder
photographer Michael Rafelson
printing Matthews, Ingham & Lake

Royal Conservatory of Music Seventy Six Percent Book ■ Canada's Royal Conservatory of Music was launching a new national education program that integrated the arts into the regular public school curriculum. It would be a costly program, and corporate support would be necessary. HM&E created this brochure that emphasizes the compelling statistical information the RCM was trying to bring forth. Tightly cropped photos of children, run in vibrant colors and overprinted with text, provoke an emotional response that successfully tugged at the heartstrings of Canada's top corporations and generated the necessary funding.

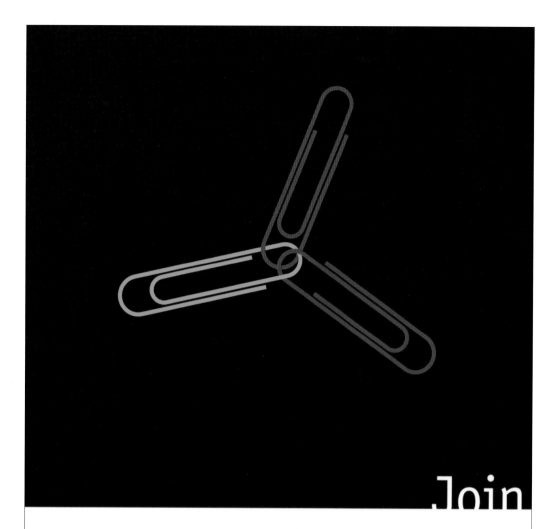

Join

Join the American Institute of Graphic Arts (AIGA) and become part of the driving influence behind the graphic design profession. Headquartered in New York City and composed of chapters in 38 states, the AIGA holds national conferences and exhibitions, produces informative publications, and offers group insurance and discounts to its members. The AIGA Atlanta chapter organizes local programs, seminars, and small talks. See how design impacts your business whether

you're in marketing, advertising, photography, design, or printing. Check out our AIGA Atlanta chapter website at **www.aiga-atl.org** or join online at AIGA National's site at **www.aiga.org**. To join, call 1-800-548-1634 or, for more information, call 404-238-0876.

Join the thousands of professionals that read *Publish* magazine, the definitive design and publishing resource. Enjoy this complimentary issue featuring "101 Hot Tips" and see the enclosed subscription offer from *Publish* for a six-month trial period.

Join the many satisfied customers of Graphic Response! Not only do they support AIGA, but their commitment to high-quality printing has also won over seventy Print Excellence Awards in the last three years. Call 404-696-9000 or see our site at www.graphicresponse.com.

design firm Office of Ted Fabella
designer Ted Fabella

AIGA Atlanta, Publish Magazine, Graphic Response Paper Clip "Join" Ad ■ Combine these three concepts: design, business, and join. Ted Fabella did in this ad for AIGA Atlanta. Fabella actually had three clients to please in this single design: AIGA, the trade magazine in which the ad would appear, and the printer who created the piece. All three contributed financially. Considering the crossover and the three interested parties, the concept of three colorful, linked paper clips seemed to say it all.

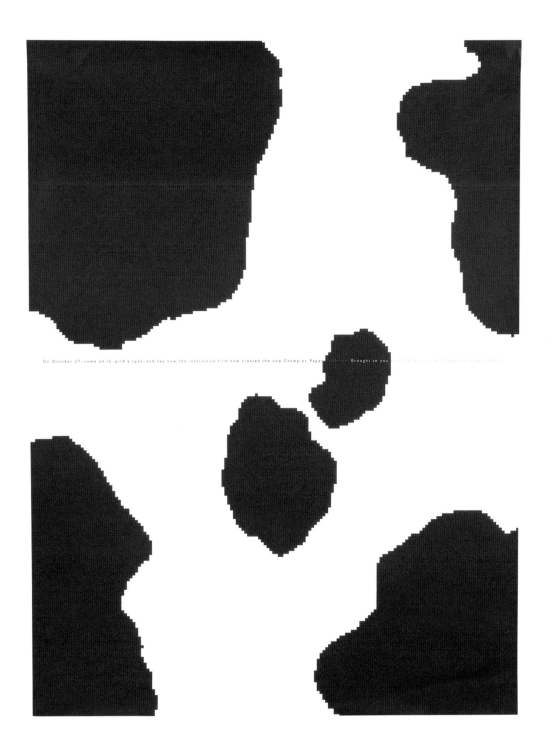

On October 27, come on in, pick a spot, and see how the interactive firm cow created the new Champion Paper website. Brought to you

design firm Office of Ted Fabella

designer Ted Fabella

Champion International, AIGA Atlanta, Cow poster ■ Champion International wanted to promote its new Web site and so invited the design firm COW to Atlanta to unveil it. COW is one of the hottest interactive firms in the country, but its name was not all that well-known at the time of the event. To create a promotional mailer, designer Ted Fabella began thinking about cows, eventually considering the bovine's spot pattern. Bitmapping an actual pattern from a cowhide created a tidy visual picture of the COW name and what the firm does.

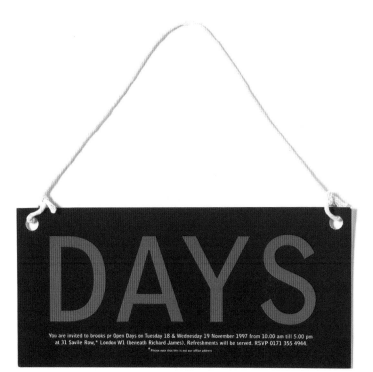

design firm @KA

designer Albert Kueh

Brooks Pr Open Days Sign ■ "Open days" is the British equivalent of the American open house, a special event hosted by a business during which customers and clients are invited to visit. As an invitation to a fashion public-relation company's open-day event, organized to promote the season's new collection, Albert Kueh of @KA created a variation of a shop's open/closed sign. Kueh reports that some recipients kept and use their sign, when they need some privacy in the office.

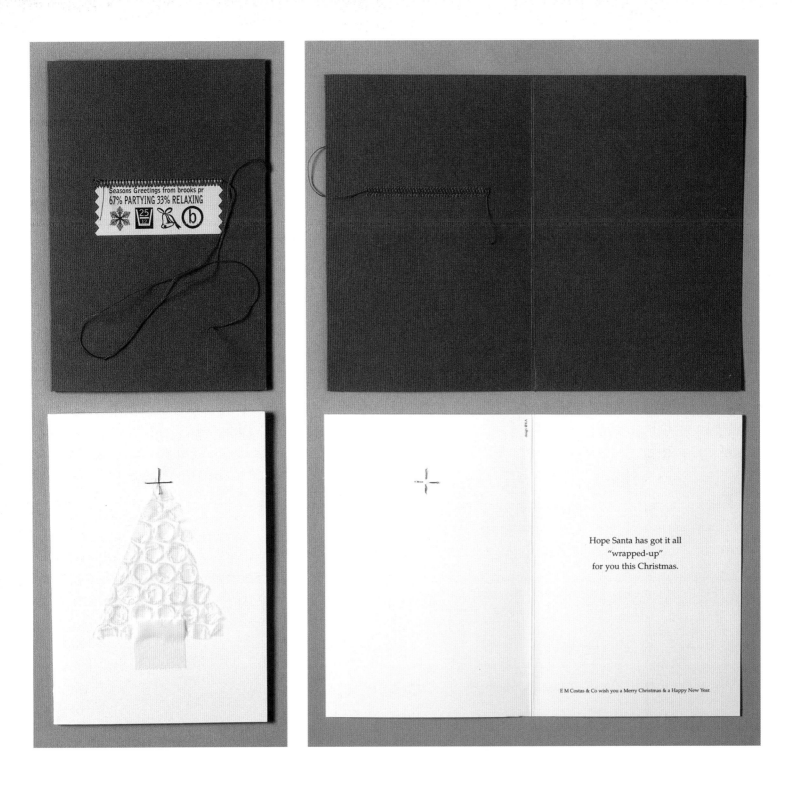

design firm @KA

designer Albert Kueh

Various Holiday Cards ■ @KA's clients range from small offices to large corporations. One thing they all have in common is the need for holiday cards. @KA uses these assignments as opportunities to show off its unique senses of design and humor. Each card is a unique conceptual match with a client's business. For instance, EM Costas & Company is a group of accountants: Its card uses rubbings of a coins arranged in a Christmas tree shape. The previous year, the firm's card took another tack: It was made entirely from materials found around the office, including bubble wrap, tape, and staples above. For a public relations company with clients in the fashion industry, a washing label stitched right on to the card tells recipients how to have a happy holiday at top.

CENSORSHIP
+
SILENCING

THE GETTY CENTER FOR THE HISTORY OF ART AND THE HUMANITIES
THE UNIVERSITY OF CALIFORNIA HUMANITIES RESEARCH INSTITUTE PRESENT

PRACTICES OF CULTURE REGULATION

In 1994–1995 a year-long program of conferences on issues of expression and repression will be presented at eight University of California campuses, California Institute of Technology, Stanford University, University of Southern California, and the Huntington Library. The topics of the conferences will range from historical consideration of the concept of the "censored" to the current controversy over the regulation of pornography. The program will culminate in a week-long seminar for invited participants at the Getty Center for the History of Art and the Humanities to be chaired by Robert Post, Professor of Law at Boalt Hall, UC Berkeley.

University of California, Berkeley
October 21, 1994
Inventing Modern Censorship
Thomas Laqueur, Townsend Humanities Center

University of California, Santa Barbara
November 4–5, 1994
*Censorship and Silencing:
The Case of Pornography*
Simon Williams,
Interdisciplinary Humanities Center

University of California, Santa Cruz
January 13–14, 1995
*Constitutions and "Serious" Stories:
Censorship, Silencing, and the Repetition
of History*

California Institute of Technology
January 28, 1995
*The Debate over "Genetics and Violence:
The Silencing of Socially Charged Science*
J. Morgan Kousser
Division of Humanities and Social Science

University of California, Irvine
January 20, 1995
*Sexuality, Silence, and Silencing:
A Transnational Perspective*
Margot Norris, English Department

Huntington Library
February 4, 1995
Liberty, Licence, and Authority
Robert C. Ritchie, Research Department

University of Southern California
February 8, 1995
*Now You See It, Now You Don't:
Procedural Justice and Substantive Meaning
in the First Amendment*
Ronald Gottesman, English Department

Stanford University
February 9–10, 1995
*Witnessing the War or Words:
From Heal to Mapplethorpe*
Wanda Corn, Stanford Humanities Center

University of California, Riverside
February 25, 1995
*Silencing Women: Femininities,
Censorship, and Difference*
Baird Magnin, Center for Ideas and Society

University of California, San Diego
March 4, 1995
*Censorship and Silencing:
The Case of Commercial Broadcasting*
Daniel Schiller, Communications Department

University of California, Davis
April 21, 1995
*Writing Between the Lines:
Mendershon and the Art of Writing Revisited*
Georges Van Den Abbeele, French Department

University of California, Los Angeles
May 11, 1995
Silencing Sexualities
Anthony Vidler, Art History Department

design firm AdamsMorioka
art director Sean Adams
designers Sean Adams, Noreen Morioka

Getty Center for the History of Art and the Humanities Censorship Poster ■ AdamsMorioka created this evocative poster to promote a series of lectures on the subject of censorship and silencing. The image evokes Big Brother; the blurred imagery and positioning of the type evoke being kept in the dark, unable to speak or see. A basic color palette, minimal type, and very straightforward, very simple layout establish a darkly ominous mood.

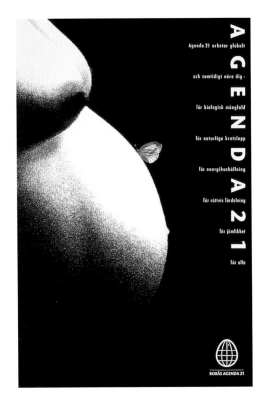

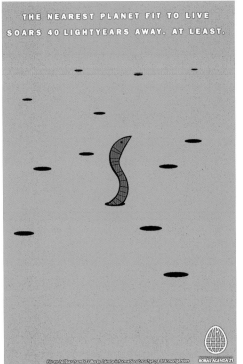

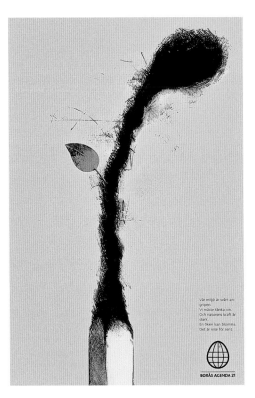

design firm Studio Bubblan

designers Kari Palmqvist, Jeanette Palmqvist

Boras Agenda 21 ■ Agenda 21 is a worldwide United Nations manifesto written to ensure the long-term survival of the human race. To succeed, the manifesto said, each country must have its own program. Studio Bubblan created these dramatic posters for Boras Agenda 21, one of the program's arms in Sweden. The posters eventually were translated into newspaper ads, magazine visuals, and even Internet images. Designer Jeanette Palmqvist says she wanted to create extremely powerful images that communicated quickly and caused people to remember Agenda 21 whenever they encounter it.

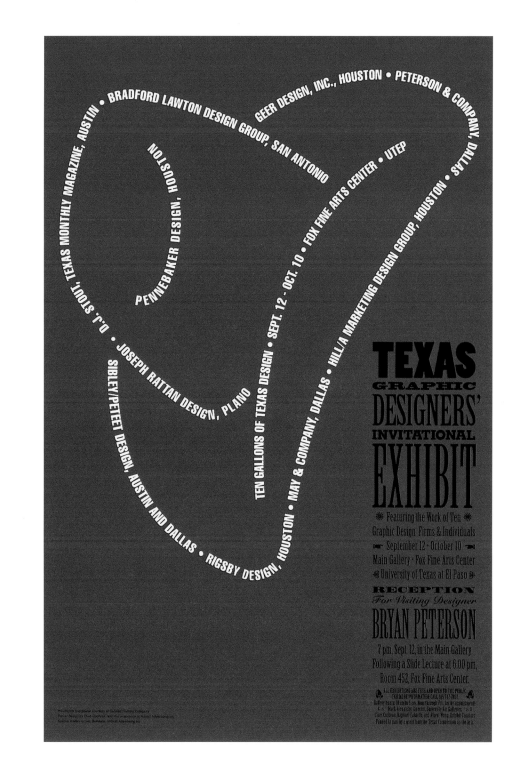

design firm Mithoff Advertising, Inc.
art director Clive Cochran
designer Clive Cochran
illustration Guynes Printing Co.

University of Texas, El Paso, Department of Art, Texas Designers Poster ■ Designer Clive Cochran wanted to create a simple, bold, iconic look in this poster for an exhibit of graphic design work. But he had a lot of information to weave in as well. To lessen the muddying effect of too much copy, he decided early on to incorporate the type as part of the illustration. But as he worked, he realized that the type could actually be the illustration. A double hit of red on the two-color poster pumped up the impact even further.

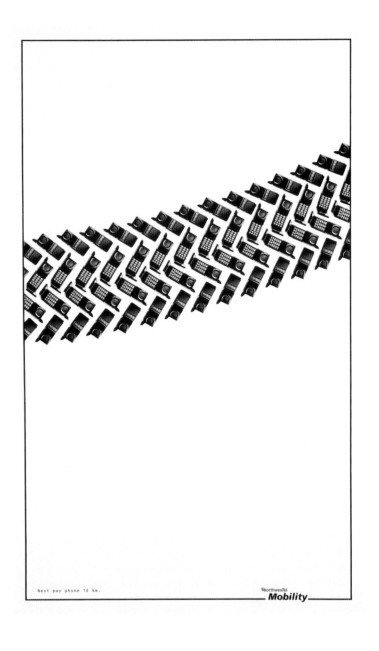

Next pay phone 16 km.

NorthwesTel
Mobility

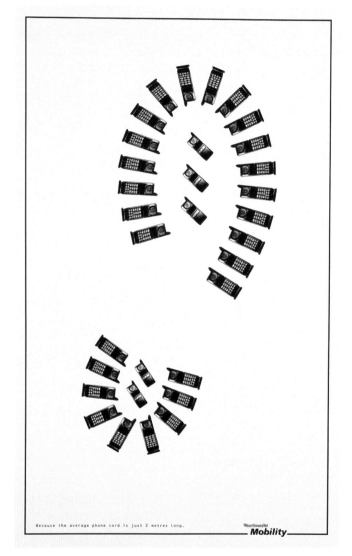

Because the average phone cord is just 2 metres long.

NorthwesTel
Mobility

design firm Palmer Jarvis DDB

designers Cosmo Campbell, Ian Grais

copywriters Marc Stoyber, Alan Russell

creative director Chris Staples

Northwestel Mobility Ads ■ The idea for these very simple ads came from trying to find a way to communicate the mobility offered by the client's cell phones. Used as full-page newspaper ads and in-store posters, the images of chunky tire tracks and heavy boots resonated well with the audiences in Canada's Northwest Territories who encounter plenty of snow and leave many footprints and tracks. A third ad used a fingerprint as a central image, illustrating the custom features the phone offered.

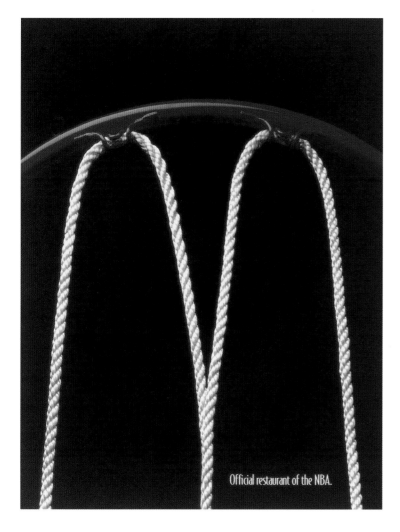

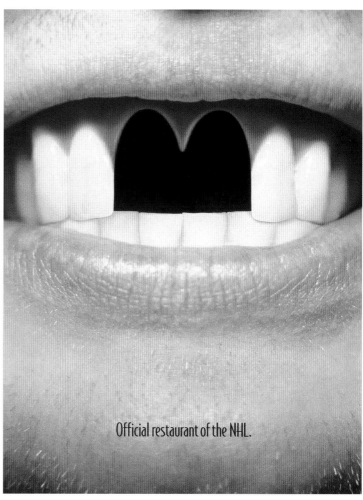

design firm Palmer Jarvis DDB
art director Dean Lee
creative director Chris Staples
illustrator Nancy Joyce
writer Marc Stoyber
photographer Robert Earnest

McDonald's Hockey and Basketball Ads ■ These unforgettable ads—for guess who—ran in game programs and were used for backlighted posters situated at entrances to the sports arenas. Dean Lee of Palmer Jarvis DDB says the fun part is that the ads don't even mention the client's name, but everyone knows exactly who it is.

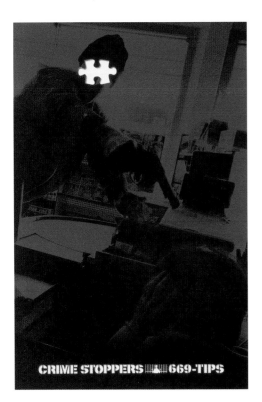

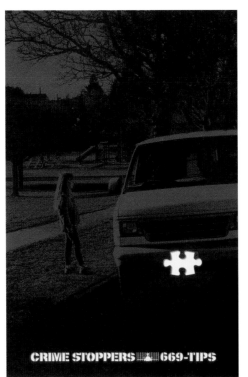

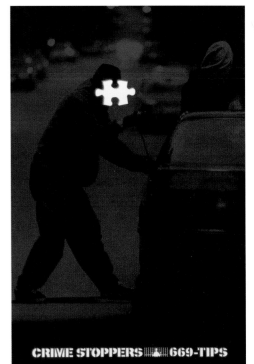

design firm Palmer Jarvis DDB

creative directors Chris Staples, Ian Grais

art director Ian Grais

copywriter Alan Russell

Crime stoppers Ads ■ Because the main venue for these posters would be in transit shelters, designers at Palmer Jarvis DDB knew they would have to be a powerful, fast read. The idea for the puzzle analogy came from the notion that a tip is really just a piece of information, and sometimes a crucial piece of information can help solve a crime. The familiar icon of the missing puzzle piece drove home the fact that what an individual knows or sees can be very important.

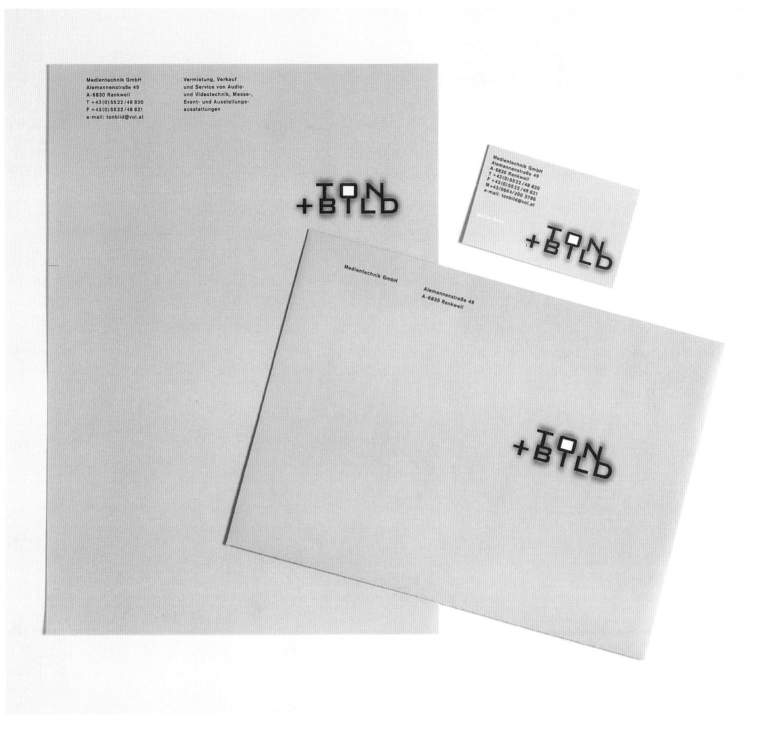

design firm Peter Felder Grafikdesign
art director Peter Felder
designers René Dalpra, Peter Felder

Ton + Bild Identity ■ For Ton + Bild ("sound and picture"), a firm that produces audio-visual shows and videos, designer Peter Felder created an identity that combines seeing and hearing—and he built the mark entirely from type. The *O* at the center of the design could be a screen, a microphone, or a loud speaker. On second sheets and other applications, the mark can be used by itself.

NORTH^BOUND

design firm Atelier Works
designer Quentin Newark

Northbound Logo ■ The inspiration for this logo, designed by Atelier Works for a management consultancy, is a management model that compares a company to a train, its CEO to the train's driver, and its employees to passengers. The conductor declares the train is going in one direction—north—and all the passengers must be either willing to go north or get off the train. The consultancy's name and logo not only represent this model, they also symbolize where the firm is proud to be located: in the north of England.

design firm Atelier Works
art director Quentin Newark
designer Glenn Howard
typographer Glenn Howard

View Logo ■ View is a new photographic library that focuses on architecture. Its name says what each photo in the collection is—a view. Because architecture has many different styles, the logo Atelier Works created for the library had to be style-neutral. A version of Futura was adapted to have a very progressive look, and the logo was made to shine through the stationery system. Printed in fluorescent inks on translucent paper, the components are aesthetically symbolic of the light and luminosity in the View's photos.

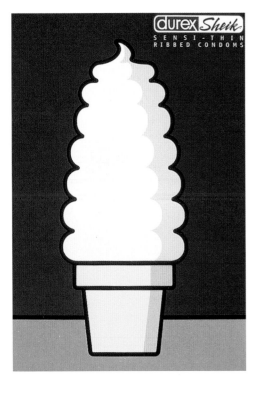
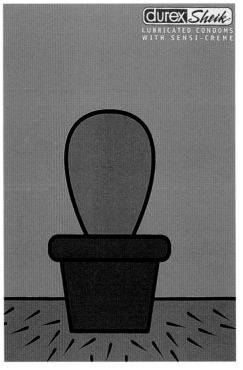

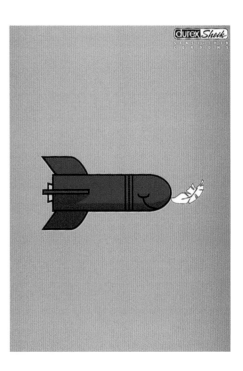

design firm MacLaren McCann
senior art director Sean Davison
senior copywriter Jonathan Freir

Durex Canada Advertisements ■ When researching approaches to an advertising campaign for Durex condoms, the creative staff at MacLaren McCann discovered that their target group—single men, 18 to 24 years of age—are tired of being preached to about how and why they should use condoms. They want advertising that respects who they are and speaks with a bit of humor, fun, and irreverence. The series of street murals, outdoor posters, rest room ads, postcards, magazines, and newspapers that have since emerged have been a perfect match. Even a switch plate with a strategically placed switch hole was developed. The attributes of specific brands are referenced in sly, humorous ways by simple illustrations that break through any environment's general clutter.

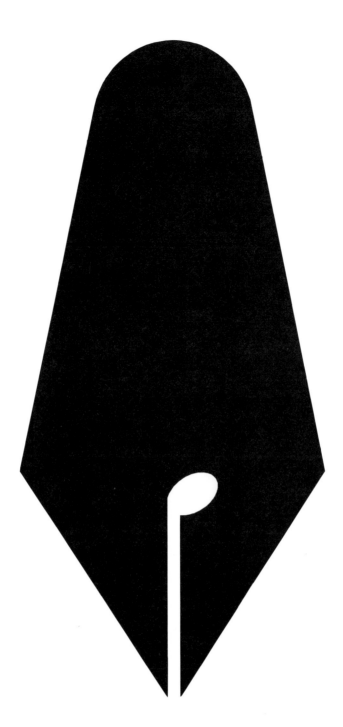

design firm Dogstar

art director Rodney Davidson

K. Lee Scott Logo ■ The idea for composer K. Lee Scott's elegant logo came to designer Rodney Davidson almost immediately. The image was in his mind before he ever began. The mark captures the concept of a composer in its most simple form. Enough said.

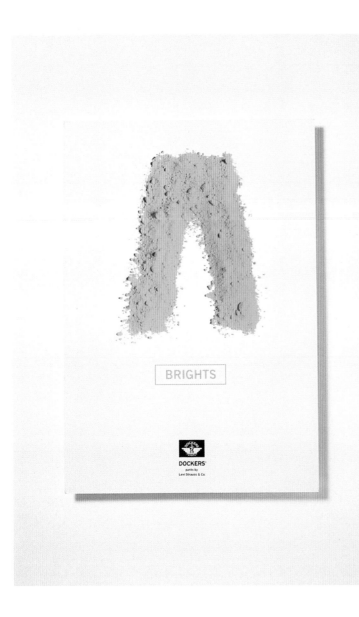

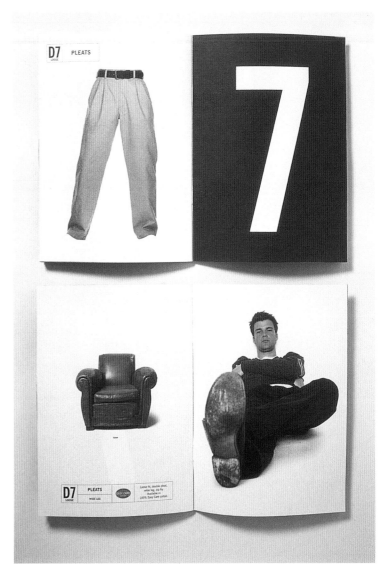

design firm Tango Design Ltd.

creative director Peter Rae

designers Roberto D'Andria, Ian Cockburn, Mark Lester (D system); Roberto D'Andria (winter fabrics); Glenn Harrison (Colours)

photographers Mark Mattock (D system); Michael Harvey (winter fabrics); Merton Gauster (Colours)

Dockers Promos ■ Dockers initially came to Tango for a new brand identity. The company had different styles of pants called Chief, Colby, Classic, Crew, and so on. To simplify the selection, Tango created a "D" system: Pants were give descriptors such as D1 and D2. Tango then developed a simple graphic language that reflected the product's uncomplicated style. The brochure (shown above) uses simple imagery as metaphors to describe the product attributes. A poster advertising ten-minute alteration service uses ten sewing needles, laid out hash mark style. Pants wrapped in brown paper promoted home delivery. For a seasonal campaign, Tango was asked to advertise three lines: Naturals, Aquas, and Brights. Again, simple metaphors worked best. Finally, for a winter fabrics promotion, Tango associated the products with heat in very direct opposite ways.

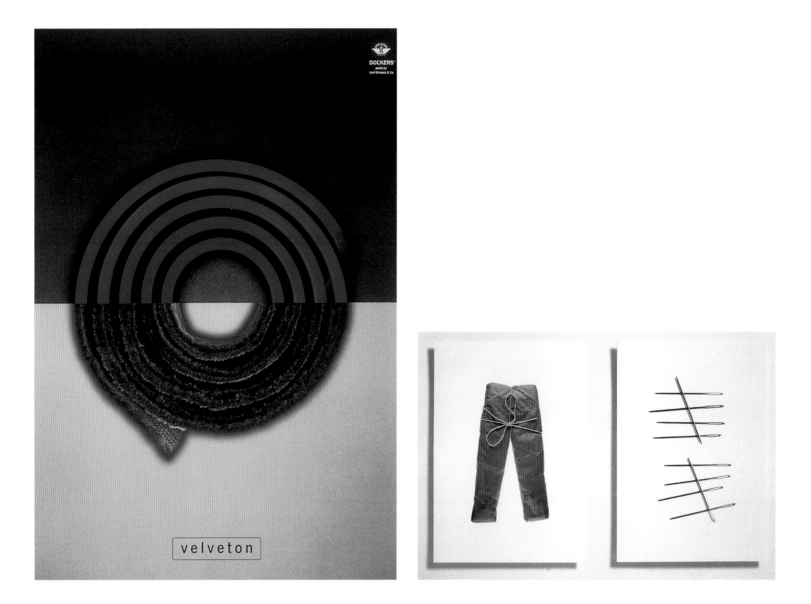

SRTECE FTFSU

NORTON TFSUF

(SECRET STUFF)™

ERSCET FUFTS

TERECS UFTSF

design firm Gee + Chung

art director Earl Gee

Symantec Secret Stuff Logo ■ While creating a brand identity for a new line of encryption software that allows users to encode and decode private messages, Gee + Chung designers took a cue from the product's function. A simple typographic solution composed of scrambled words reveals the product name and visually engages viewers.

design firm	EAI
creative directors	Matt Rollins, Phil Hamlett
designers	Matt Rollins, Todd Simmons
photographers	Various
printing	Dickson's

EAI Identity ■ The EAI identity system explores the function of design, says creative director Matt Rollins. Thirty-two different word/picture combinations appear on the business cards, and the same images are applied as stickers to letterhead and envelopes. The skillful, strategic combination of words and pictures defines the job of a communicator. Any given word or picture conjures its own set of meanings—which are different for everyone—but when combined, a pair assumes new meaning.

6.

Minimal packaging in this section does not typically refer to packaging in the conventional design sense. Instead, it refers to a design's physical assembly. A minimal package pulls together all components elegantly, almost without visible design. The package looks like a very natural and unforced solution. ■ Designs in this section exhibit a certain freedom of expression. They break from common design expectations. They assemble disparate elements surprisingly and seamlessly.

minimal package

JOKER

55555

[8]
SPADES
OF SPADES

[J]
RED
JOKER

[J]
RED

JOKER

JOKER

JOKER JOKER
JOKER
EMULATION IS NO JOKE

design firm Paper Scissors Stone
designers Lisa Ewing, Scott Cameron

Paper Scissors Stone Identity ■ Designers Lisa Ewing and Scott Cameron say their firm's name, Paper Scissors Stone, has two meanings. First, it speaks to process, from idea (paper), through development (scissors), to completed project (stone). But the name also embodies their desire to provide a complete package of design for clients, from graphics to furniture, lighting, and interior design. On a lighter note, they say, it also names the game by which they make some decisions—best two out of three. The stylistic elements on their letterhead reflect a refined, modern approach to design: Ewing and Cameron feel that their business papers are a proper introduction to their personality and style.

design firm Emery Vincent Design
art director Garry Vincent

Fosters United Brewing Group Wall Display ■ Fosters United Brewing Group needed a case to display all of its many products. But it also needed a design consonant with the modern corporate-culture design throughout its offices, which included sleek brass and aluminum panels. Emery Vincent created a display that dominated an entire room: Bottles sit between steel fins and are backlighted for additional drama. The case became an architectural element rather than a simple piece of furniture.

design firm Turner Duckworth
art directors David Turner, Bruce Duckworth
designers Bruce Duckworth, Bob Celiz

Neal's Yard Toiletries ■ Old-fashioned blue bottles haven't been used as packaging in recent times. But by adding delicate frosting and labels in fresh, modern colors to Neal's Yard packaging, Turner Duckworth designers turned traditional bottles into modern icons. The palette is bright, fresh, and contemporary, chosen to draw attention to the product at the point of purchase—and they also look great on the bathroom shelf.

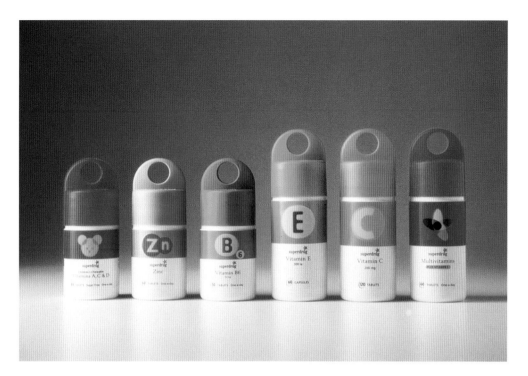

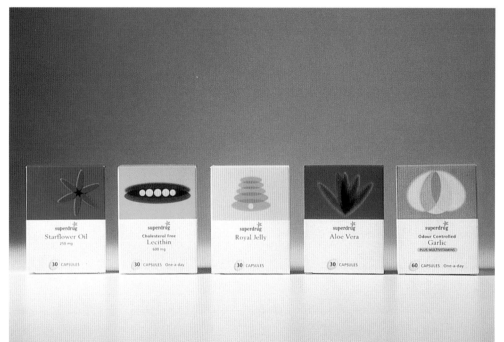

design firm Turner Duckworth
art directors David Turner, Bruce Duckworth
designer Bruce Duckworth
illustrator Justin DeLavison

Superdrug Products ■ Turner Duckworth designers chose bright, lively colors for this line of Superdrug products to convey life and health. They also created pill or capsule-shaped illustrations to reference minimally the packages' contents. The design of the lidded bottles was created especially for Superdrug: Keeping the elderly and arthritic in mind, the designers created an ergonomically correct childproof cap. The bottle can easily be opened by inserting a pencil in the lid for more leverage. Superdrug also is designing a hook system that would allow the consumer to hang the bottles for storage.

design firm Turner Duckworth

art directors David Turner, Bruce Duckworth

designer Bruce Duckworth

Ashima Monofilament Package ■ Ashima manufactures more than 100 kinds of fishing line and hooks. To keep everything straight at the company's warehouse, on the retailer's shelf, and in the buyer's tackle box, Turner Duckworth designers created a simple color-coding system. The bright, simple labels are applied to static-free bags that protect the fishing line from ultraviolet light, which can degrade the product over time.

Shepard

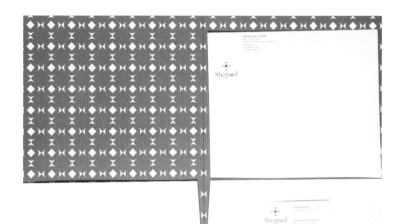

ROBYN ANDERSON
Transportation Supervisor

Shepard

SHEPARD LOGISTIC SERVICES
1531 Carroll Drive, NW
Atlanta, Georgia 30318-3605
404.720.8602
404.720.8750 fax
770.890.0885 beeper

design firm Sage
art director Vicki Strull
designer Vicki Strull
illustrator Vicki Strull

Shepard Exposition Services Folder and Stationery ■ Shepard is a convention services company that plans, coordinates, and implements trade shows and conventions, all from behind the scenes. The business is fraught with challenges and problems, and Shepard constantly must find solutions, often fitting square pegs into round holes. This metaphor became the basis for the company's logo, created by the design firm Sage. As the hole expands beyond the boundaries of the outer square, explains principal Vicki Strull, that outer square becomes four arrows, signifying Shepard's growth nationally. For the inside of the client's presentation folder, Strull gives the simple logo another spin: She created a pattern that not only resembles the map of booths at a trade show, but also communicates the crowded feeling of such a gathering.

design firm Sage
art director Vicki Strull
designer Vicki Strull
illustrator Vicki Strull

Sage Stationery ■ Vicki Strull chose Sage for the name of her business because of its multiple invocations: the herb, the color, and the quality of a wise person. The appropriate illustration was evident—the sage leaf, whose graphic she uses subtly. The color choice for her identity was obvious, and she plays simply between the mossy, green ink and crisp, white paper. Finally, the quality of sagacity is communicated through the entire design's quiet, reserved stance.

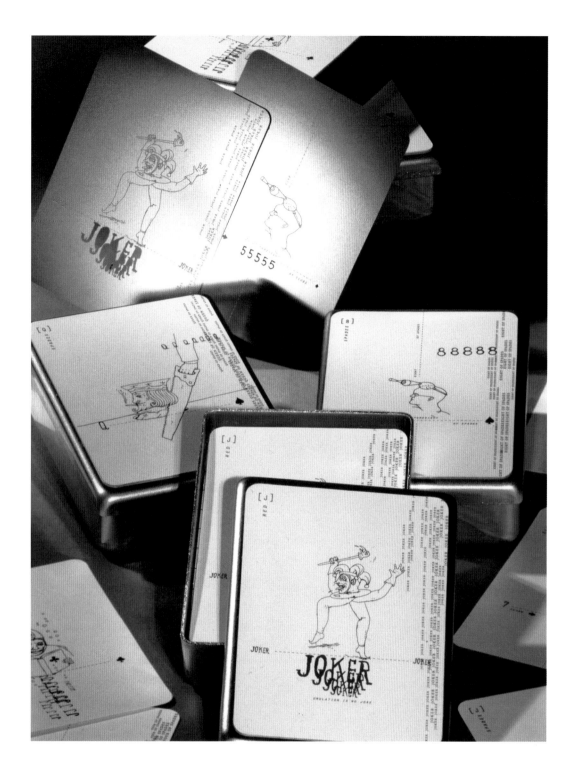

design firm	Sterling Design
art director	Jennifer Sterling
designer	Robert Pollie
illustrators	Jonathon Rosen, Jennifer Sterling

Quickturn Playing Cards ■ Quickturn Design Systems supplies design verification solutions that allow those in the electronics industry to test their chip designs before committing to fabrication. To communicate its marketing message, "The Magic of Emulation," at a major conference, the firm asked Sterling Design to create a promotional item that matched the theme and would not be thrown away after the conference. Jennifer Sterling devised an unusual, minimalist deck of cards housed in a metal case. One side of each card illustrates humorous magical attempts; the other carries the marketing message. The result is a useable deck of cards that also can be read almost like a book.

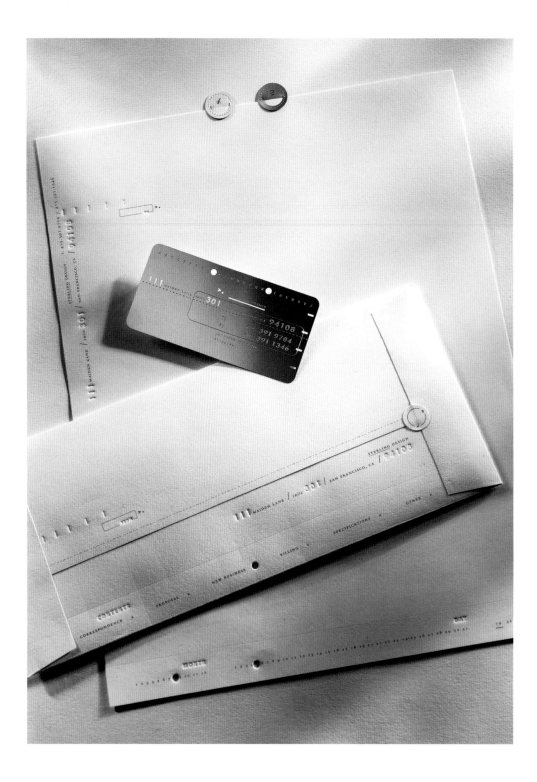

design firm	Sterling Design
creative director	Jennifer Sterling
typographer	Jennifer Sterling

Sterling Design Identity System ■ Jennifer Sterling wanted to create an identity system for her firm that represented both two- and three-dimensional design sensibilities. Her solution was a multimedia one: The business card is a stamped and laser-cut metal card; it represents her three-dimensional work. The holder's initials are die-cut from the alphabet at the top of the card. The letterhead and envelope carry embossed numbers and lettering; for more texture and interest, small die-cuts indicate the date and reason for the correspondence. The blind embossing, tiny holes, and small amount of actual printing produce a minimalist feel for the system.

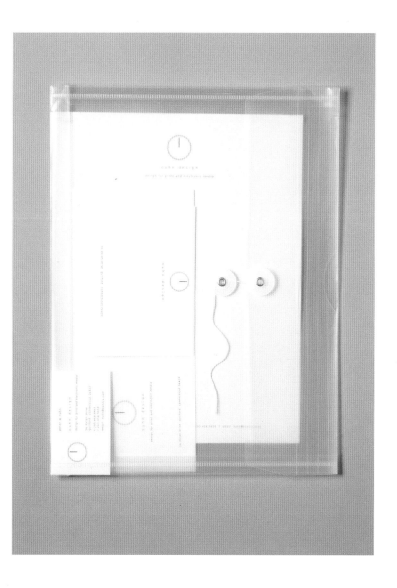

peter w nuhn

n u h n d e s i g n

design for print and electronic media

56 dolan drive
guilford connecticut 06437

t 203.458.9457
f 203.458.9459

email nuhn@connix.com

design firm	Nuhn Design
art director	Peter W. Nuhn
designer	Peter W. Nuhn

Nuhn Design Stationery and Logo ■ Designer Peter Nuhn's last name is pronounced "noon." The idea for his logo-as-rebus grew from a story his mother told him. As a high school teacher, his mother had to teach her students how to remember the pronunciation of her name, so she told them they could call her Mrs. Twelve O'clock. Nuhn says he turned this memory game into a modernist visual.

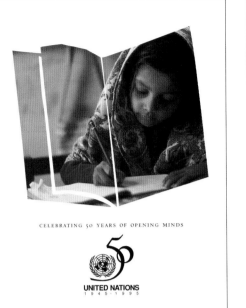

CELEBRATING 50 YEARS OF OPENING MINDS

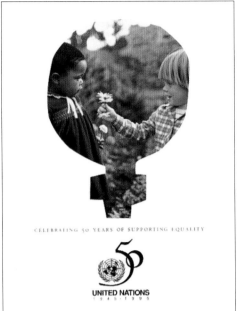

CELEBRATING 50 YEARS OF SUPPORTING EQUALITY

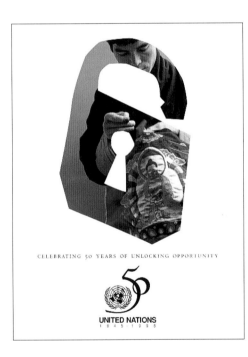

CELEBRATING 50 YEARS OF UNLOCKING OPPORTUNITY

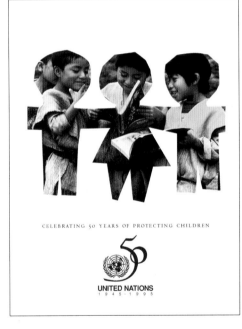

CELEBRATING 50 YEARS OF PROTECTING CHILDREN

design firm Joe Advertising
designer Sharon Occhipinti
copywriter Sharon Occhipinti

United Nations Advertisements ■ To celebrate its fifty years of service, the United Nations wanted a series of ads that would communicate the event anywhere in the world. Sharon Occhipinti developed an image-within-an-image approach that not only translated internationally, but also references many things the UN does for people around the world.

design firm	Blackbird Creative
design director	Patrick Short
senior designer	Kristy Benusoleil
copywriter	Brad Bray
photographer	Brad Bridgers
production	Amy Bareclou

Loaves & Fishes Promotion ■ Loaves & Fishes is a nonprofit organization that provides one week's worth of groceries to families temporarily in over their economic heads. To generate corporate and private donations for the group, Blackbird Creative designed a brochure that visually explains what drives the organization. Wrapped in grocery bag paper and a check-out tape, the brochure design succeeded so well that corporate donations rose 40 percent and food donations 300 percent. Loaves & Fishes even had to open two additional facilities to take care of the generous overflow.

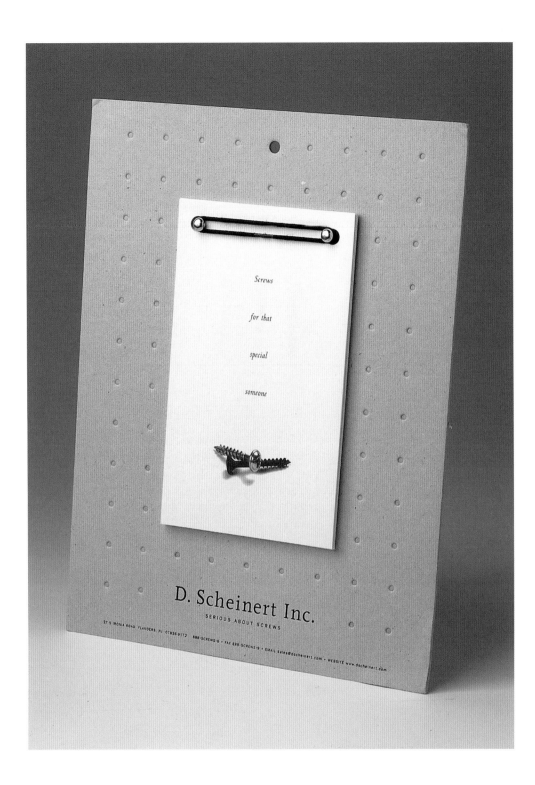

Screws

for that

special

someone

D. Scheinert Inc.
SERIOUS ABOUT SCREWS

27 5 IRONIA ROAD, FLANDERS, NJ 07836-9172 • 888-SCREWS-6 • FAX 888-SCREWS-9 • EMAIL Sales@dscheinert.com • WEBSITE www.dscheinert.com

design firm Viva Dolan Communication and Design
art director Frank Viva
designer Victoria Primicias
copywriter Doug Dolan
photographer Hill Peppard

D. Scheinert Inc. Calendar ■ Viva Dolan Communication and Design's client, D. Scheinert, wanted a catalog that was useful and invoked usefulness. The company also wanted to distinguish itself from the other promotions that buyers of screw products typically receive: serious, masculine, devoid of design. Viva Dolan devised an elegant solution: A calendar/catalog is bound by screws and an elasticized band to a piece of letterpress-printed chipboard. The "dents" in the board were applied with an old letterpress using plastic plates. They evoke a sense of screw holes, and the grid-like placement evokes precision.

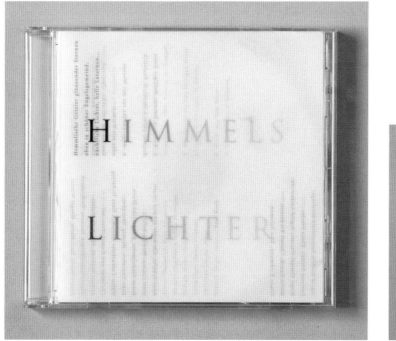

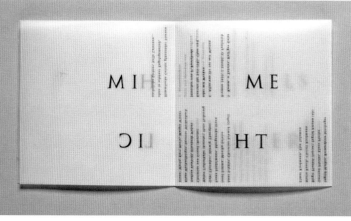

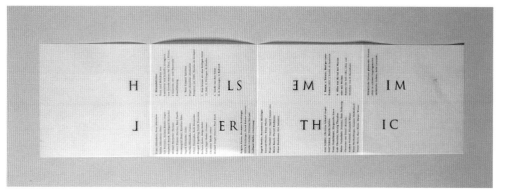

design firm Peter Felder Grafikdesign

art director Peter Felder

designer Peter Felder

illustrator Gebhard Mathis

Rankler Chörle CD ■ Printed on transparent paper, the copy on this CD insert recedes into itself when folded, an apt visual metaphor for the spiritual music on the disk. Typography becomes more and more transparent, like light fading beyond fog or clouds. When the booklet is open, the reader sees that single letters form a complete word only when the booklet is closed. Analogously, the fifty individual singers recorded on the CD become one voice as a chorus.

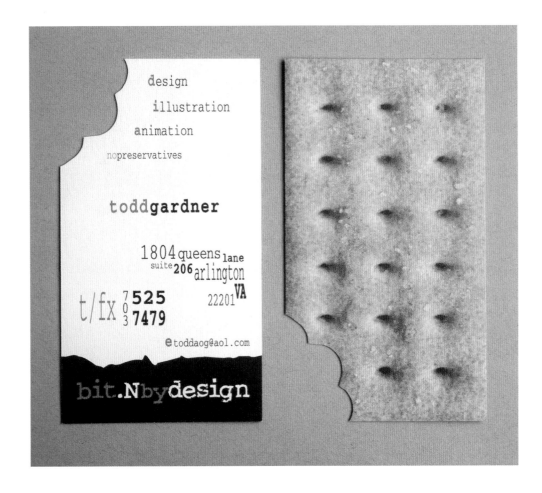

design firm bit.Nbydesign
designer Todd Gardner

bit.Nbydesign Business Card ■ Todd Gardner discovered the perfect business card design for his business, bit.Nbydesign, while he was eating a bowl of soup. The card-as-cracker, its corner bitten off with a die-cut, was simple and memorable. Gardner says that most recipients smile or laugh when he gives them a card. Some thought he was handing them a real cracker.

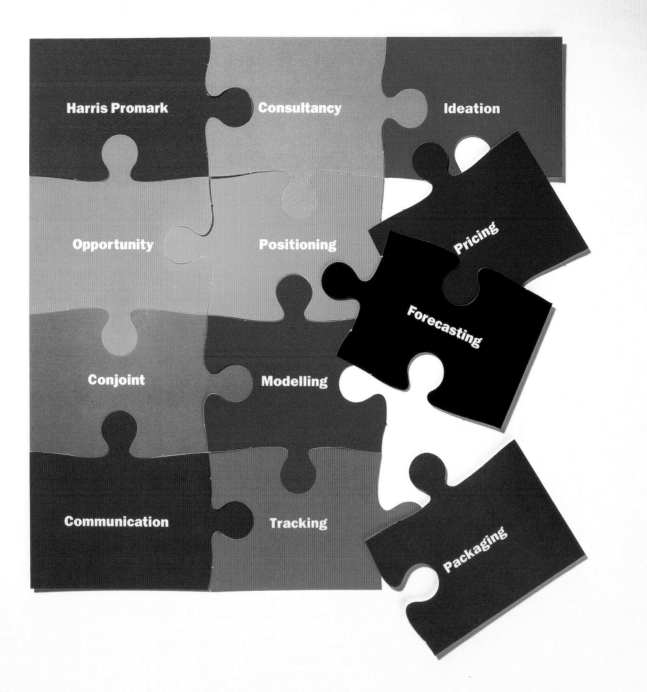

design firm Atelier Works
art director John Power
designer Ben Acornley
typographer Ben Acornley

Harris Promark Puzzle Pieces ■ Harris Promark provides complex research and consultancy services related to the product launch and cycle of pharmaceutical products. To relate all of its client's very involved and technical services, Atelier Works designed a puzzle that was sent out as a mailer and given out at trade shows. The design is strong and memorable, says art director John Power, even if you don't understand all the terminology.

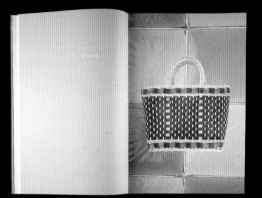

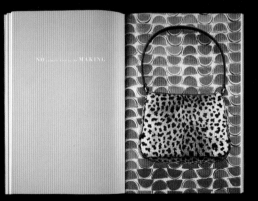

design firm Jeanette Hodge Design
art director Jeanette Hodge
designer Jeanette Hodge
copywriter Deborah Bishop
photographer Robert Cardin
bookbinder John DeMerritt

George Hensler and Co. Purse Book ■ As a private label manufacturer for pocketbooks and accessories, George Hensler and Co. wanted a portfolio that demonstrated the authenticity, quality, and humor inherent to its designs. Jeanette Hodge presented her client's pocketbooks in a way that accents the playfulness and construction of the Hensler designs against contrasting, textural backgrounds. The presentation is simple, unique, and memorable.

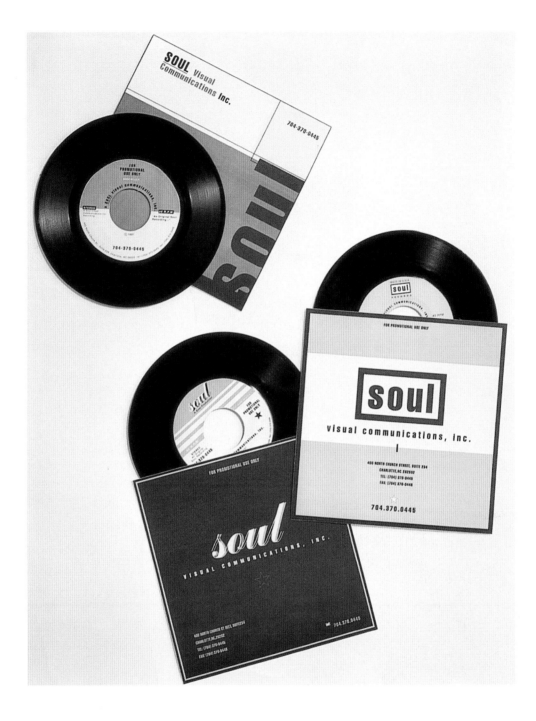

design firm SOUL Visual Communications
designer David Eller

Soul Promo Records ■ With a name like SOUL Visual Communications, the firm's designers have had plenty of opportunities to dream up conceptual associations to the word *soul*, one of which is the musical connection. As part of a self-promotional campaign, SOUL designers decided to distribute their own records—not recordings, but playful samples of package design as simple 45 labels and sleeves.

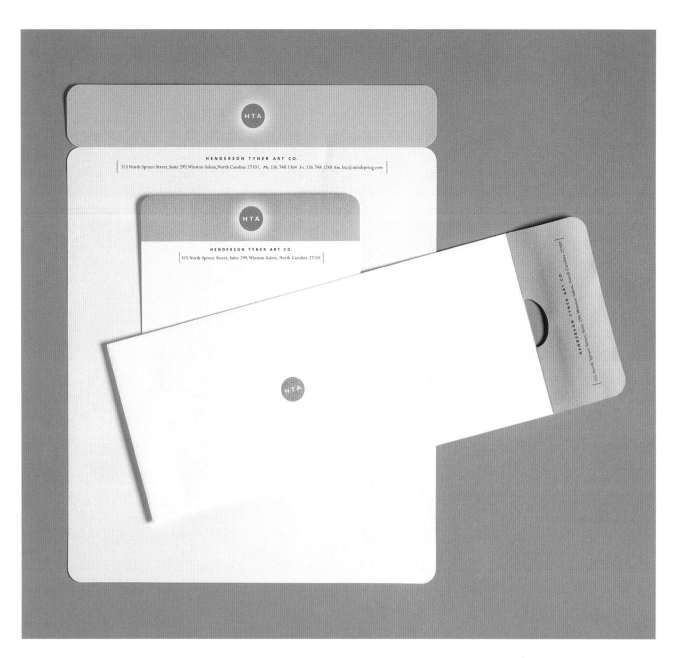

design firm Henderson Tyner Art Company

creative directors Troy Tyner, Hayes Henderson

copywriter Troy Tyner

Henderson Tyner Art Company Identity and Stationery ■ "Tasteful restraint" was Henderson Tyner's approach to its current identity system. Principal Troy Tyner stipulated, keep it smart and don't try to be too clever. Silver and sage balance each other: warm and cool, innovative and classic. The embossed "pill" was incorporated for impact. Usually, people expect something visual, Tyner says. When they get something tactile with the visual, they register more impact.

design firm Tango Design Ltd.
art director Peter Rae
designer Roberto D'Andria
photographer Polly Eiles

Vamp Identity ■ Vamp, an event-organization company, has a reputation for producing some very off-the-wall occasions. One recent party was held in a multistory car park in central London's Soho district, with small golf carts ferrying guests about. At another event, the entire bar was sculpted out of ice. Tango designers felt that Vamp's identity also must reflect the unusual. Their solution is to place everyday items out of context. They offered no explanation. Like Vamp's work, the design puts the recipient slightly off-kilter.

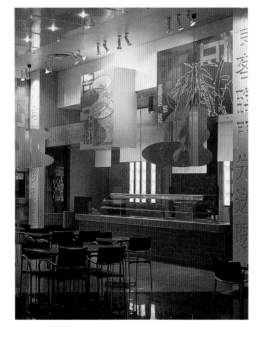

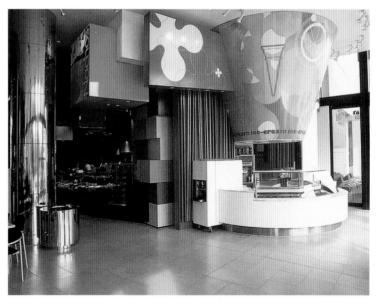

design firm Cornwell Design Party

Crown Casino Food Court ■ Food courts typically are competitive, noisy environments. A hungry and indecisive crowd faces a multitude of flavors, aromas, and sounds. Cornwell Design's concept for the Crown Casino Food Court was meant to help people decide what to eat. Each food vendor's venue displays a contemporary graphic interpretation of its particular cuisine. The iconographic signage can be recognized instantly, and it complements its architectural surroundings.

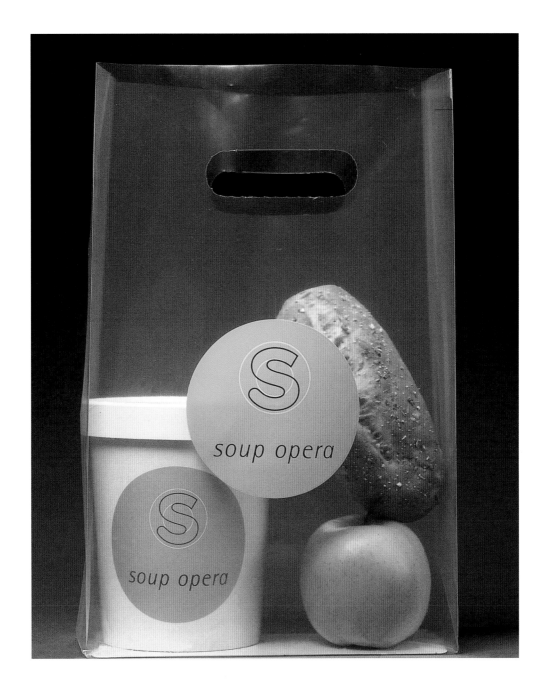

design firm Lippa Pearce Design, Ltd.

art directors Dominic Lippa, Harry Pearce

designer Rachael Dinnis

Soup Opera Identity ■ First there were coffee bars; now there are soup bars. Soup Opera, its name playing off of "soap opera," is one that now has two outlets in London. Its aim is to serve healthy, natural meals as an alternative to conventional fast food: Patrons receive soup, a roll, and a piece of fruit for their meal. The identity Lippa Pearce Design Ltd. created for Soup Opera matches the client's brand values and physically displays the store's openness in sharing the soup's ingredients. The look is pure, cosmopolitan, and modern.

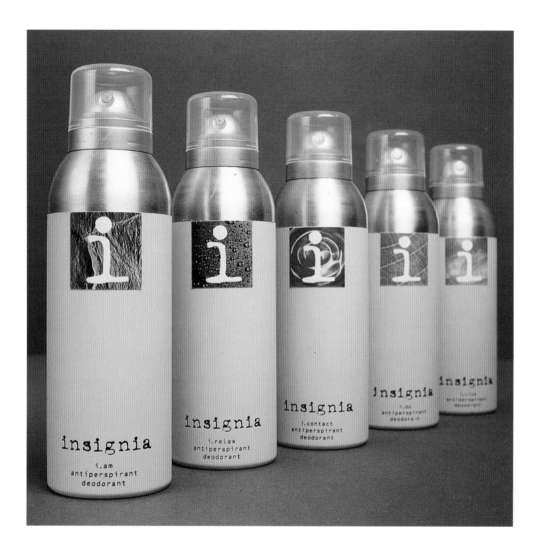

design firm Lippa Pearce Design, Ltd.
art director Harry Pearce
designers Harry Pearce, Paul Tunnicliffe
copywriter Paul Tunnicliffe

Dana UK Insignia Identity ■ A 1980s design, dominated by black, used to promote the brand Insignia, a men's fragrance for years. When another company bought the brand, the new owner asked Lippa Pearce Design, Ltd. to create a new identity that was not so overpowering or predatory. Research showed that today's men are much more self-assured and prefer more subtle fragrances. The design solution is clean, contemporary, and modern, and it reinforces the notion of individuality.

design firm Mirko Ilić Corp.

art director Mirko Ilić

Museum of Modern Art, Rijeka, Croatia, Book, Stationery, and Envelope ■ For this stationery, Mirko Ilić developed its design from the cover of a catalog for the *14th International Exhibition of Drawings* at the Museum of Modern Art at Rijeka, Croatia, and from the familiar comics convention of frames or cels. The designer intended that people who use the letterhead and envelopes write in the cels he provides. He has had a lot of fun seeing how people fill in the stationery: Creative writing abounds, he notes.

irect-ory

■ @KA
42 Leamington Toad Villas
London WH11 1WT UK
Contact: Albert Kueh

■ AdamsMorioka
9348 Civic Center Drive#450
Beverly Hills, CA 90210
Contact: Sean Adams

■ Arian, Lowe & Travis
343 West Erie
Chicago, IL 60610
Contact: Julie Mikos

■ Art 270, Inc.
741 Yorkway Place
Jenkintown, PA 19046
Contact: Carl Mill

■ Ashley Booth Design
Sagveien 23 C 11
0458 Oslo, Norway
Contact: Ashley Booth

■ Atelier Works
The Old Piano Factory
5 Charlton Kings Road
London NW5, UK
Contact: Quentin Newark

■ Michael Bartalos
30 Ramona Avenue, #2
San Francisco, CA 94103
Contact: Michael Bartalos

■ Baumann + Baumann
Taubentalstrasse 4/1
73525 Schwäbisch, Germany
Contact: Barbara Baumann

■ bit.Nbydesign
1804 Queens Lane, #206
Arlington, VA 22201
Contact: Todd Gardner

■ Blackbird Creative
100 N. Tryon Street, Suite 2800
Charlotte, NC 28202
Contact: Patrick Short

■ Brian J. Ganton & Associates
882 Pompton Avenue
Cedar Grove, NJ 07009
Contact: Brian J. Ganton Jr.

■ Buck & Pulleyn
500 Helendale Road
Rochester, NY 14609
Contact: Chris Lyons

■ Büro Für Gestaltung
Domstrasse 8A
D-63067 Offenbach, Germany
Contact: Albrecht Hotz

**■ Consolidated Graphics
& FIREPOWER Design Co.**
449 North Baldwin Street
Madison, WI 53703
Contact: Mark S. Macaulay

■ CORE
1136 Washington Avenue
St. Louis, MO 63101
Contact: Eric Tilford

■ Cornwell Design Party
Level 1/35 Little Bourke Street
Melbourne, Victoria, Australia 3000
Contact: Jane Sinclair

■ Cummings & Good
3 North Main Street
Chester, CT 06412
Contact: Christopher J. Hyde

■ Dogstar
626 54th Street S.
Birmingham, AL 35212
Contact: Rodney Davidson

■ EAI
887 W. Marietta Street NW, Ste. J-101
Atlanta, GA 30318
Contact: Dawn Gahan

■ Elberson Senger Shuler
5950 Fairview Road
Charlotte, NC 28210
Contact: John F. Roberts Jr.

■ Emery Vincent Design
80 Market Street
Southbank, Victoria 3006 Australia
Contact: Garry Emery

■ Fairly Painless Advertising
44 East 8th Street
Holland, MI 49423
Contact: Chris Cook

■ Frank Baseman Design
21 Mather Road
Jenkintown, PA 19046
Contact: Frank Baseman

■ FUSE
c/o CORE
1136 Washington Avenue
St. Louis, MO 63101
Contact: Eric Tilford

■ Gee + Chung
38 Bryant Street, Suite 100
San Francisco, CA 94105
Contact: Earl Gee

■ Geer Design
2518 Drexel Drive, Suite 201
Houston, TX 77027
Contact: Mark Geer

■ George Tscherny, Inc.
238 East 72 Street
New York, NY 10021
Contact: George Tscherny

■ **Haley Johnson Design Co.**
3107 East 42nd Street
Minneapolis, MN 55406
Contact: Haley Johnson

■ **Diane Fitzgerald Harris**
170 Fernboro Road
Rochester, NY 14618
Contact: Diane Fitzgerald Harris

■ **Henderson Tyner Art Company**
315 North Spruce Street
Winston-Salem, NC 27101
Contact: Troy A. Tyner

■ **HM&E. Inc.**
20 Maud Street, Suite 501
Toronto, Ontario MSV 2M5, Canada
Contact: Paul Haslip

■ **J. Cole Phillips Design**
26 Merrymount Road
Baltimore, MD 21210
Contact: Jennifer Phillips

■ **Jay Carskadden Graphic Design**
3131 Western Avenue, #504
Seattle, WA 98121
Contact: Jay Carskadden

■ **Jeanette Hodge Design**
471 Linden Street
San Francisco, CA 94102
Contact: Jeanette Hodge

■ **Joe Advertising**
44 Grey Rocks Road
Wilton, CT 06897
Contact: Sharon Occhipinti

■ **Jon Flaming Design**
2200 North Lamar, Suite 222
Dallas, TX 75202
Contact: Jon Flaming

■ **Kym Abrams Design. Inc.**
213 West Institute Place
Suite 608
Chicago, IL 60610
Contact: Kym Abrams

■ **Landesberg Design Associates**
1100 Bingham Street
Pittsburgh, PA 15203
Contact: Rick Landesberg

■ **Larsen Interactive**
7101 York Avenue South
Minneapolis, MN 55435
Contact: Catherine Gillis

■ **Lippa Pearce Design. Ltd.**
358A Richmond Road
Twickenham TW1 2DV, UK
Contact: Domenic Lippa

■ **Lisa Billard Design**
580 Broadway, #709
New York, NY 10012
Contact: Lisa R. Billard

■ **MacLaren McCann**
100 Courtland Avenue
Concord, Ontario L4K 3T6, Canada
Contact: Sonya Agnew

■ **Mad Dogs & Englishmen**
126 5th Avenue, 12th Floor
New York, NY 10011
Contact: Nick Cohen

■ **MarketSights**
3040 Cambridge Place, NW
Washington, DC 20007
Contact: Marilyn Worseldine

■ **Martin/Williams**
60 South 6th Street, Suite 2800
Minneapolis, MN 55402
Contact: Jim Henderson

■ **Miriello Grafico**
419 West G Street
San Diego, CA 92101
Contact: Ron P. Miriello

■ **Mirko Ilić Corp.**
207 East 32 Street
New York, NY 10016
Contact: Mirko Ilíc

■ **Mithoff Advertising. Inc.**
4105 Rio Bravo
El Paso, TX 79902
Contact: Clive Cochran

■ **Modern Dog**
7903 Greenwood Avenue
Seattle, WA 98103
Contact: Robynne Page

■ **Muller + Company**
4739 Belleview
Kansas City, MO 64112
Contact: John Muller

■ **Nesnadny + Schwartz**
10803 Magnolia Drive
Cleveland, OH 44106
Contact: Mark Schwartz

■ **Nestor-Stermole Visual Communications**
19 West 21, #602
New York, NY 10010
Contact: Okey Nestor

■ **Niklaus Troxler Grafik Studio**
PO Box 6130
Bahnhofstrasse 22
Postfach
6130 Willisau, Switzerland
Contact: Niklaus Troxler

■ **Nuhn Design**
56 Dolan Drive
Guilford, CT 06437
Contact: Peter W. Nuhn

■ **Office of Eric Madsen**
123 North Third Street
Suite 600
Minneapolis, MN 55401
Contact: Eric Madsen

■ **Office of Ted Fabella**
1271 Moores Mill Road
Atlanta, GA 30327
Contact: Ted Fabella

■ **Palmer Jarvis DDB**
1700 777 Hornby Street
Vancouver, BC V62 2T3
Contact: Dean Lee

■ **Paper Scissors Stone**
3131 Western Avenue, #514
Seattle, WA 98121
Contact: H. Scott Cameron

■ **The Partnership**
512 Means Street, Suite 400
Atlanta, GA 30318
Contact: David Arnold

■ **Pentagram Design**
204 Fifth Avenue
New York, NY 10010
Contact: Jim Brown

■ **Perich & Partners**
100 Briarwood Circle
Ann Arbor, MI 48108
Contact: Rebecca von Zastrow

■ **Peter Felder Grafikdesign**
Alemannenstrasse 49
A-6830 Rankweil, Austria
Contact: Peter Felder

■ **PYRO**
c/o CORE
1136 Washington Avenue
St. Louis, MO 63101
Contact: Eric Tilford

■ **Rigsby Design**
2309 University Blvd.
Houston, TX 77005
Contact: Thomas Hull

■ **Sage**
4068 Vinings Mill Trail
Smyrna, GA 30080
Contact: Vicki Strull

■ **Scorsone/Drueding**
212 Greenwood Avenue
Jenkintown, PA 19046
Contact: Alice E. Dreuding

■ **Siegel & Gale**
10 Rockefeller Plaza
New York, NY 10020
Contact: Cheryl Heller

■ **Slaughter Hanson**
2100 Morris Avenue
Birmingham, AL 35203
Contact: Clara Jackson Young

■ **Sommese Design**
481 Glenn Road
State College, PA 16803
Contact: Lanny Sommese

■ **SOUL Visual Communications**
1318 #A-10 Central Avenue
Charlotte, NC 20205
Contact: David Eller

■ **Sterling Design**
5 Lucerne, Suite 4
San Francisco, CA 94103
Contact: Jennifer Sterling

■ **Studio Bubblan**
Sjunde Villagatan 28
S-502 44 Borås, Sweden
Contact: Kari Palmqvist

■ **Studio Dolcini Associati**
Via Mentana 3
47900 Rimini, Italy
Contact: Leonardo Sonnoli

■ **Sunspots Creative, Inc.**
51 Newark Street, Suite 205
Hoboken, NJ 07030
Contact: Richard Bonelli

■ **SVP Partners**
15 Cannon Road
Wilton, CT 06897
Contact: Jean Page

■ **Tango Design Ltd.**
Newcombe House
45 Notting Hill Gate
London W11 3LQ, UK
Contact: M. Drese

■ **Ted Bertz Graphic Design**
190 Washington Street
Middletown, CT 06457
Contact: Catherine Kesten

■ **Turner Duckworth**
164 Townsend, #8
San Francisco, CA 94107
Contact: David Turner

■ **Viva Dolan Communication and Design**
1216 Yonge Street, Suite 203
Toronto MYT IWI
Contact: Frank Viva

■ **West and Vaughan**
112 South Duke Street
Durham, NC 27701
Contact: Shawn Brown

■ **Zuckerman Fernandez + Partners**
130 Sutter Street
San Francisco, CA 94104
Contact: Lori Sebastian,